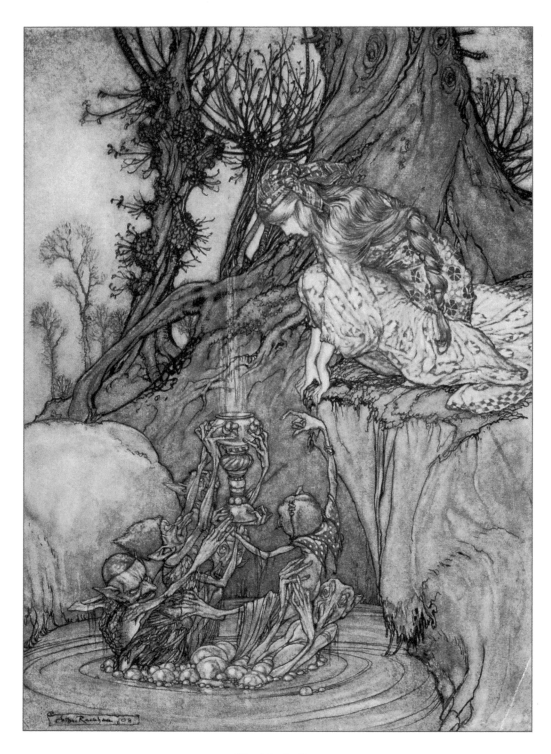

The Magic Cup
ARTHUR RACKHAM'S BOOK OF PICTURES

THE ARTHUR RACKHAM TREASURY

86 Full Color Illustrations

SELECTED AND EDITED BY
JEFF A. MENGES

Dover Publications
Garden City, New York

This Dover edition, first published in 2005, is a new selection of illustrations taken from original editions. See "Table of Contents" for details on sources.

The Publisher would like to thank The Bridgeman Art Library International Ltd. for their assistance in the publication of this volume.

ISBN-13: 978-0-486-44685-1
ISBN-10: 0-486-44685-9

Printed in Canada by Marquis Book
44685913 2024
www.doverpublications.com

INTRODUCTION

A century ago, in 1905, the 38-year-old British illustrator Arthur Rackham became a key figure in a publishing revolution. In completing 51 color pieces for a classic Early American tale, Rackham created a work that was to become a turning point in the production of books. The recent perfection of color-separated printing had made the accurate reproduction of color artwork possible, and British publisher William Heinemann found the perfect marriage in this pairing of Rackham with Washigton Irving's *Rip Van Winkle,* an atmospheric tale of rustic America. The book became an instant classic, and popularized the production of lavishly illustrated gift editions of well-known tales—a trend that delighted both publishers and consumers. Arthur Rackham became a minor celebrity and one of the most prolific and consistent illustrators of the twentieth century. Some of the most classic and defining images we carry in our minds from tales which have impressed generations of readers come from the books that reflect his life's work.

Following his success with *Rip Van Winkle,* the London-born Rackham interpreted one classic after another almost annually, ranging from *Aesop's Fables,* to *Gulliver's Travels,* to Richard Wagner's epic work, *Siegfried.* His subjects appealed to and entertained the smallest of children, while the sophistication he lent to his images not only drew in their parents, but also captured the attention of galleries and museums the world over. Today his originals are treasured rarities seldom seen outside of museums.

Rackham's early work years were spent as a clerk, but all the while, he took on jobs for various British magazines, working to develop his skills, and find a style of his own. Rackham's book-illustration career began as early as 1893. Throughout the 1890s, each assignment helped to solidify the look that we have come to identify with Rackham: strong ink work, filled with detail; and, where there was color, it was used sparingly, and with a very natural pallette. Every element of every picture breathed life.

The work represented here starts with images from *Rip Van Winkle,* the book that first brought Rackham to fame in 1905, to the end of his career. His last work was

INTRODUCTION

for Kenneth Grahame's *Wind in the Willows*, a project he had wanted to do since it was first offered to him in 1907. (He had to turn it down due to contractual obligation.) He finished work on it shortly before his death in September of 1939.

The plates selected for this volume represent a broad spectrum of Rackham's book work. All have been chosen for their draftsmanship, delicate color, or strong story-telling element that raised that particular image a notch above its companion pieces. Over 400 color plates were reviewed in first-edition or early printings to assemble the 86 that were selected for this volume.

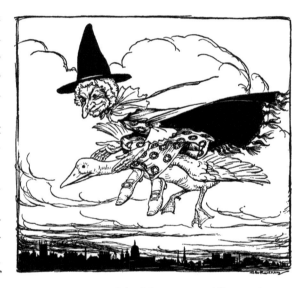

Stand out collections in his career include *Alice's Adventures in Wonderland*, which appeared in the year that followed his landmark *Rip Van Winkle*. Shakespeare's *Midsummer Night's Dream* was directed to a more adult market, but the incredible fairy imagery ensured it would last long in the memory of all who were to view it, child or adult. Rosetti's *Goblin Market* is concise, but Rackham's design sense, from the end leaves, to the front-matter decorations, to the vibrant color plates, make it a gem to find in any booklover's collection. Of special note in this group is *Arthur Rackham's Book of Pictures*. Unlike the other books, this was not a story provided by a specific author, but a collection of pictures which Rackham had done for a variety of reasons, some simply to explore his own ideas. It was, as the title suggests, of his own making, and contained some brilliant pieces.

Arthur Rackham gave his generation's children images that defined imaginative literature. Goblins, fairies, knights, and his incredible woodlands all roamed the pages that Rackham created. Generations that followed have returned to these same pages, proving the mettle of his creative genius. He became the leading British figure in what is called the Golden Age of Illustration, a period that included contemporaries like Edmund Dulac and the Brothers Robinson in England, and Howard Pyle and his Brandywine School in America. He was a giant among this group, considered by many the premier illustrator of his day.

Jeff A. Menges
June, 2005

TABLE OF CONTENTS

TABLE OF CONTENTS

THE PLATES

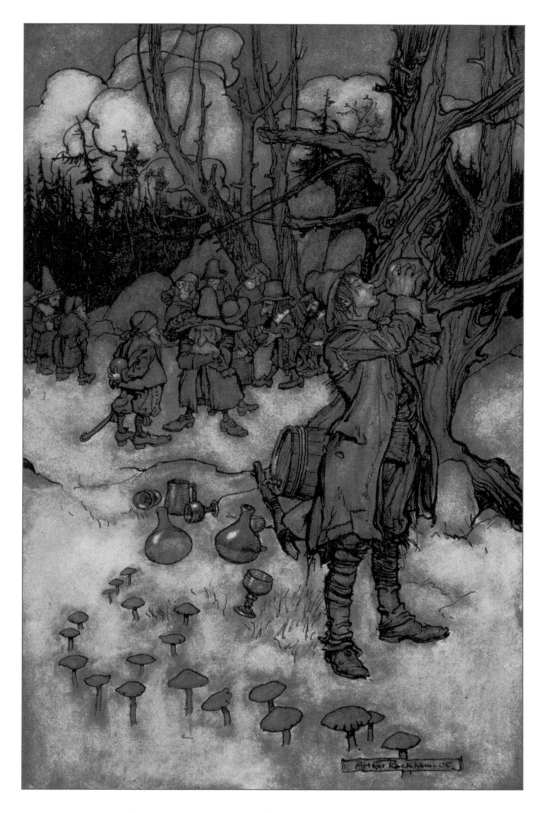

He even ventured to taste the beverage, which he found
had much of the flavour of excellent Hollands.

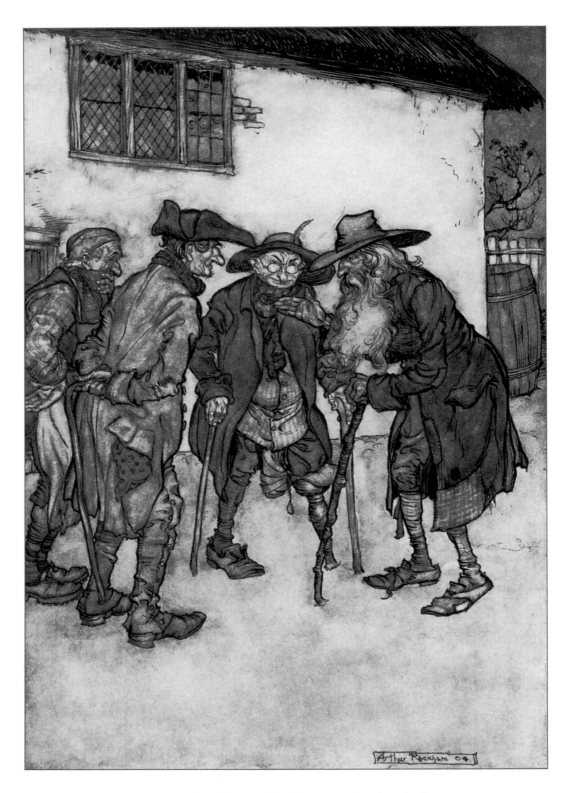

He soon found many of his former cronies, though all
rather the worse for the wear and tear of time.

PLATE 2 RIP VAN WINKLE

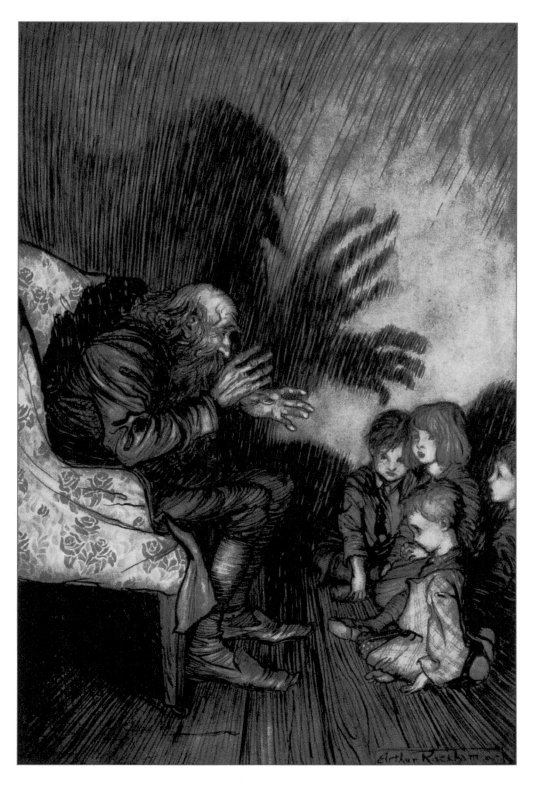

He preferred making friends among the rising generation,
with whom he soon grew into great favor.

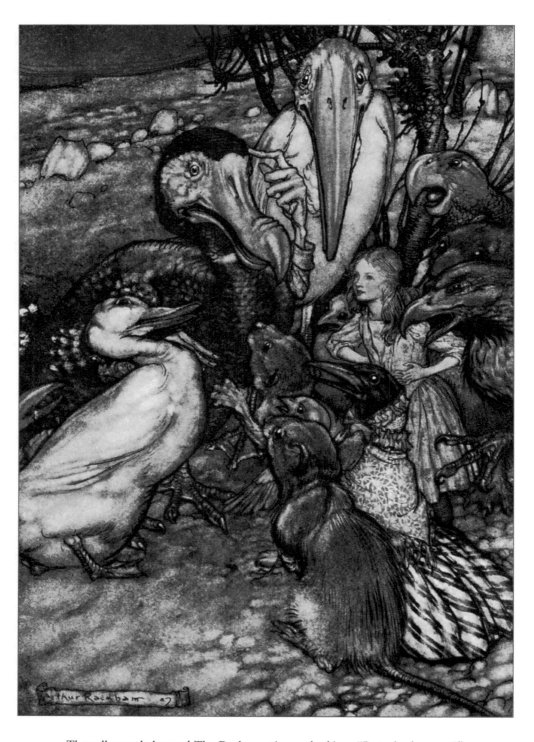

They all crowded round The Dodo panting and asking, "But who has won?"

PLATE 4 ALICE'S ADVENTURES IN WONDERLAND

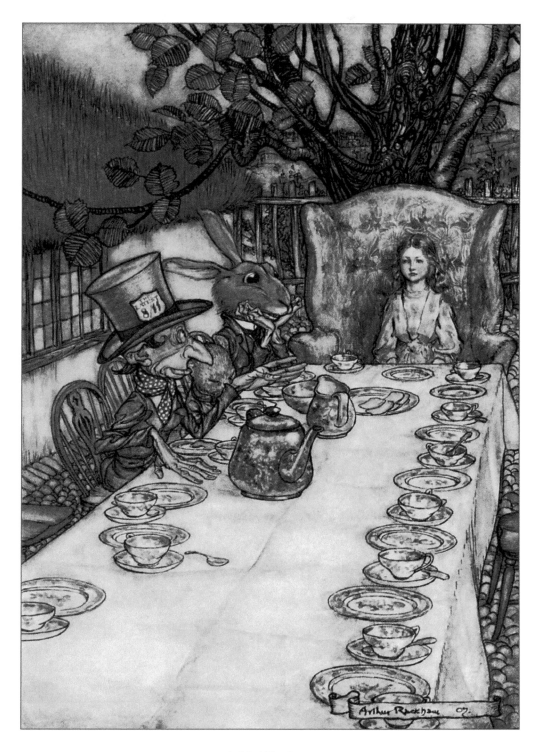

A Mad Tea Party

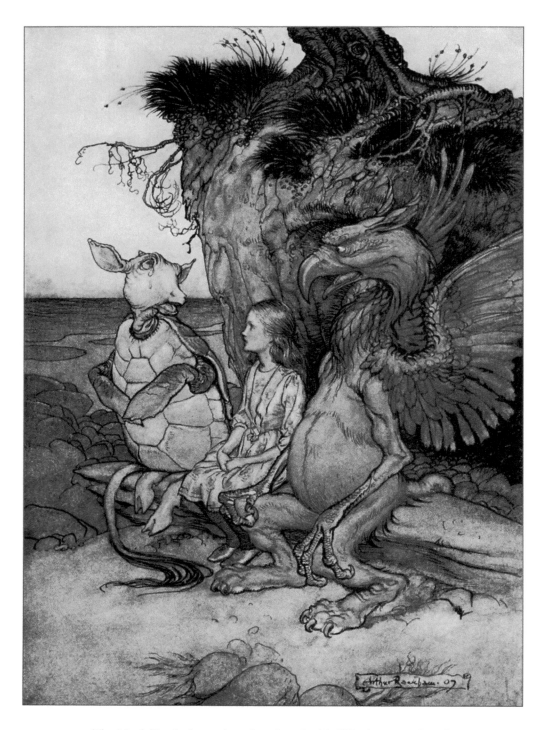

The Mock Turtle drew a long breath and said, "That's very curious."

PLATE 6 ALICE'S ADVENTURES IN WONDERLAND

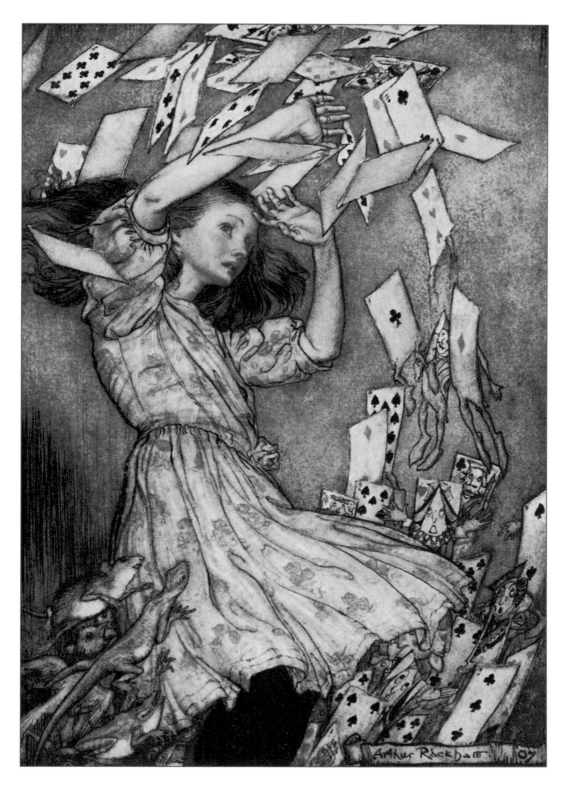

At this the whole pack rose up into the air, and came flying down upon her.

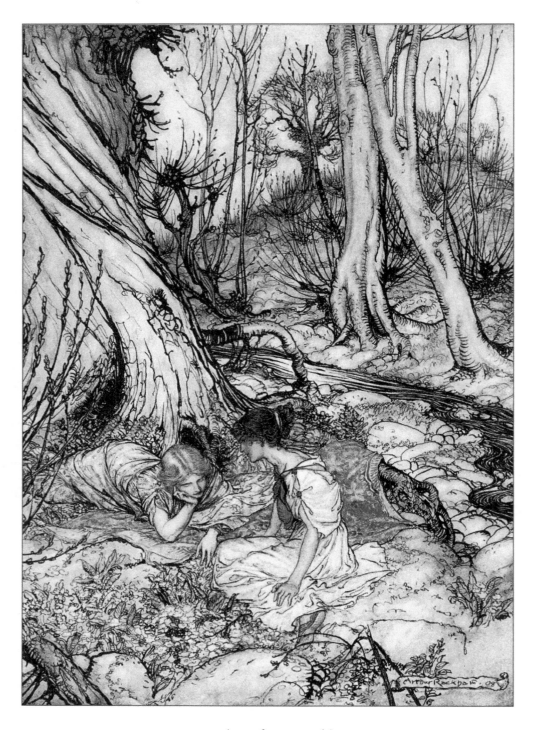

. . . where often you and I
Upon faint primrose-buds were wont to lie,
Emptying our bosoms of their counsel sweet
Act I, Scene I

PLATE 8 A MIDSUMMER NIGHT'S DREAM

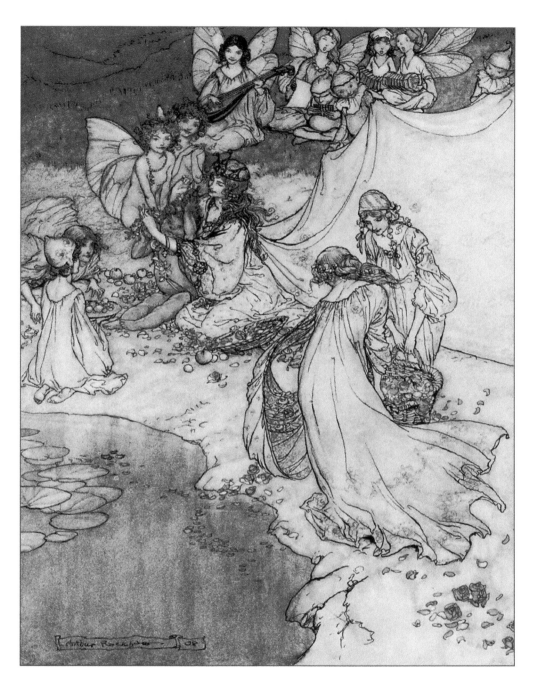

She never had so sweet a changeling
Act II, Scene I

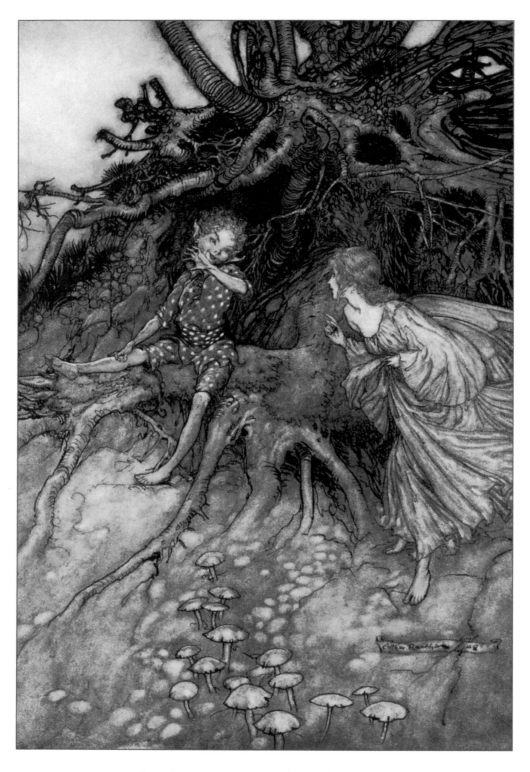

I am that merry wanderer of the night
Act II, Scene I

PLATE 10 A MIDSUMMER NIGHT'S DREAM

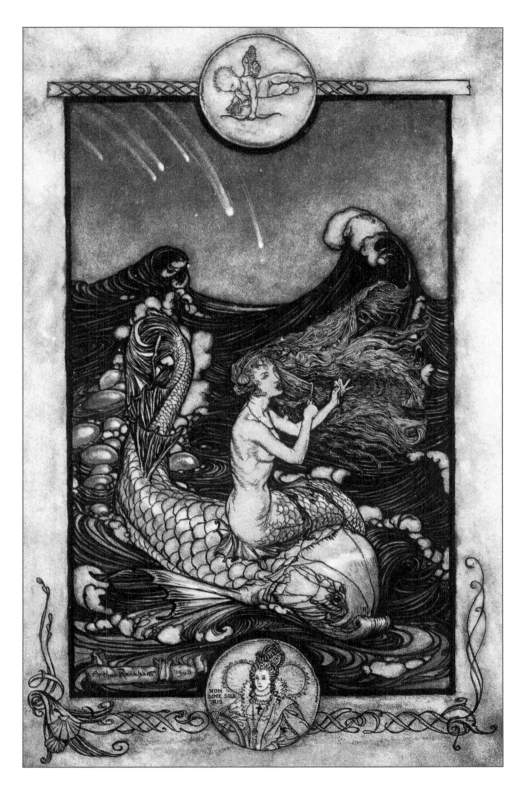

To hear the sea-maid's music
Act II, Scene I

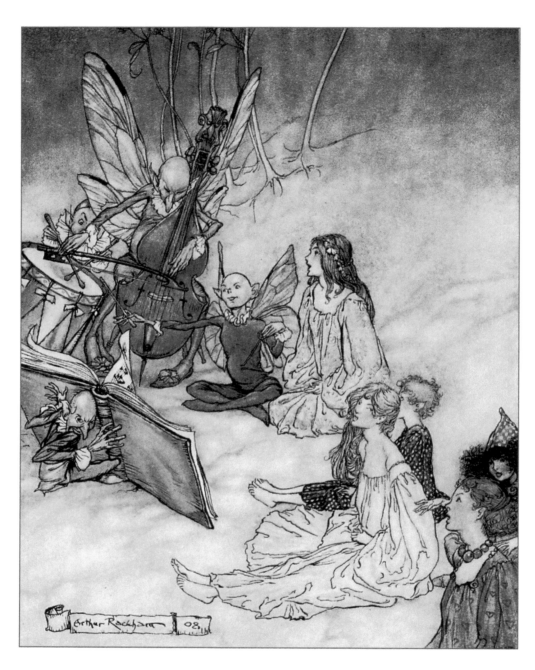

And a fairy song
Act II, Scene II

PLATE 12 **A MIDSUMMER NIGHT'S DREAM**

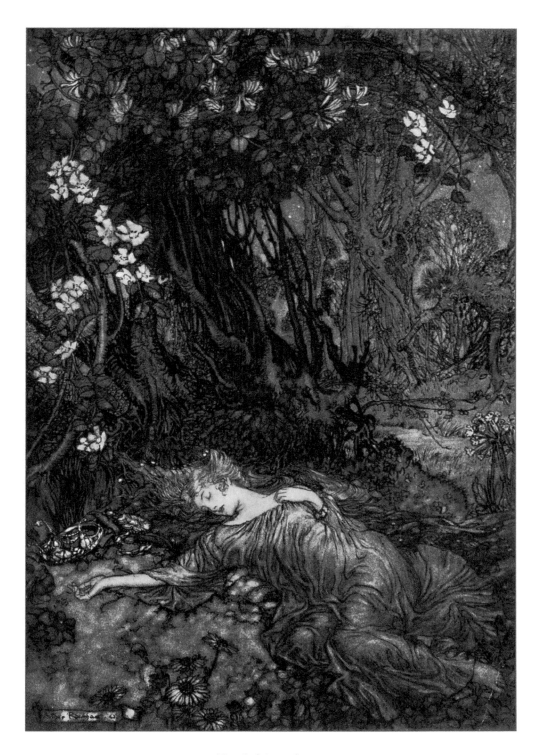

Titania lying asleep.
Act III, Scene I

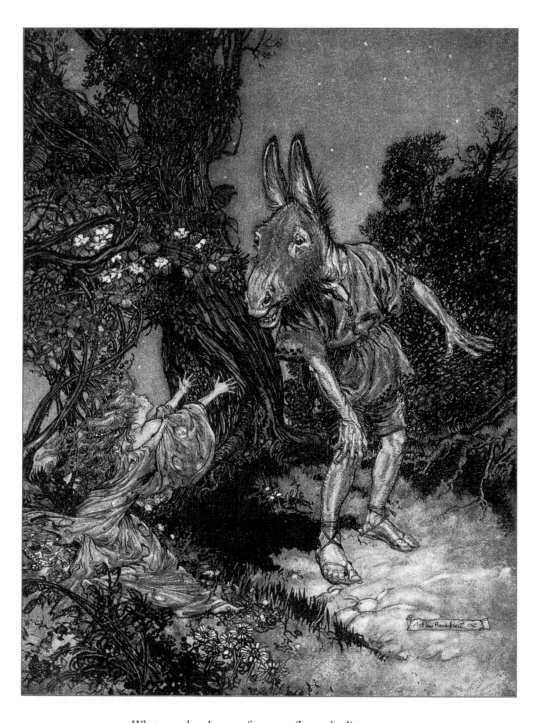

What angel wakes me from my flower bed?
Act III, Scene I

PLATE 14 **A MIDSUMMER NIGHT'S DREAM**

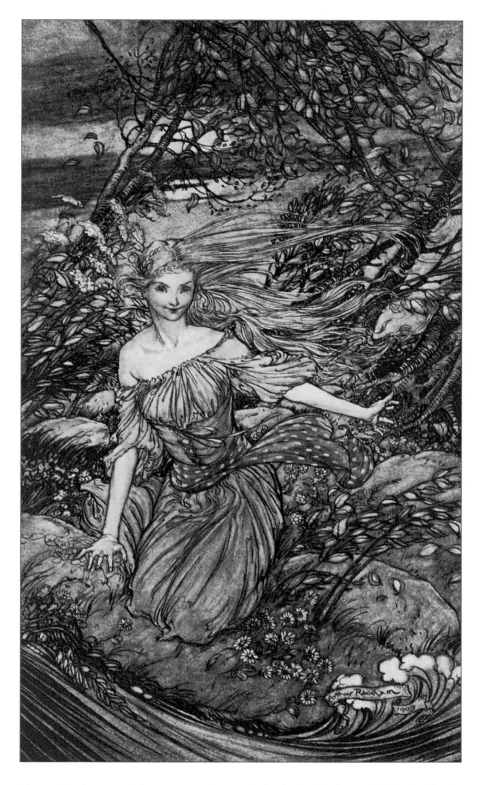

He saw by the moonlight momentarily unveiled, a little island encircled by the flood;
and there under the branches of the overhanging trees was Undine.

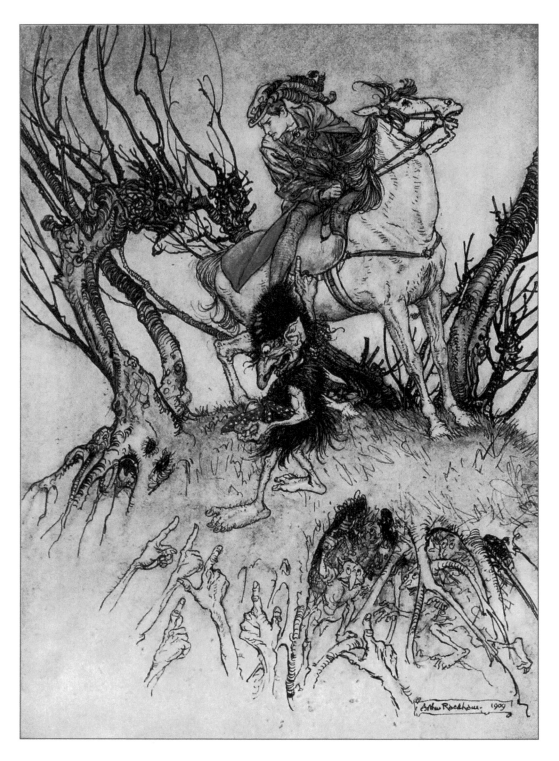

At length they all pointed their stained fingers at me.

PLATE 16 UNDINE

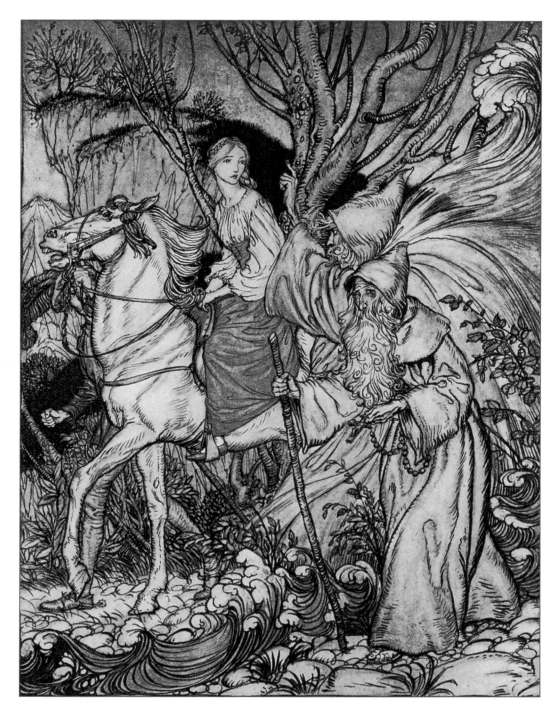

"Little niece," said Kühleborn,
"forget not that I am here with thee as a guide."

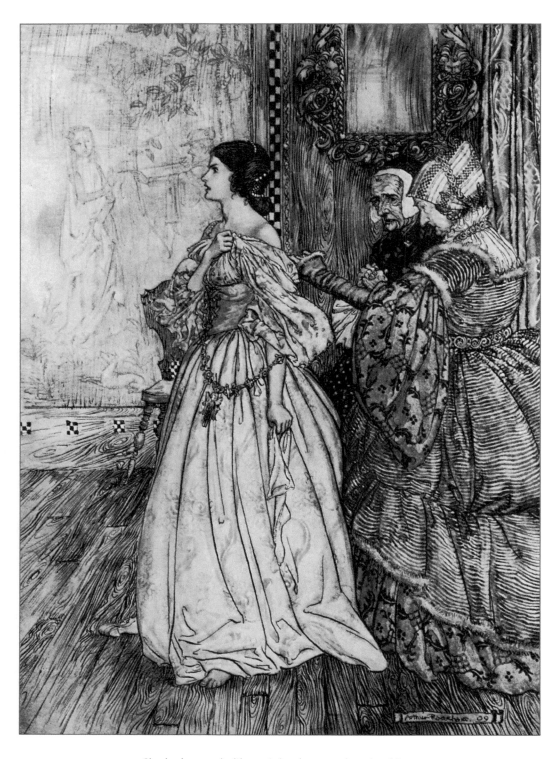

She hath a mark, like a violet, between her shoulders,
and another like it on the instep of her left foot.

PLATE 18 UNDINE

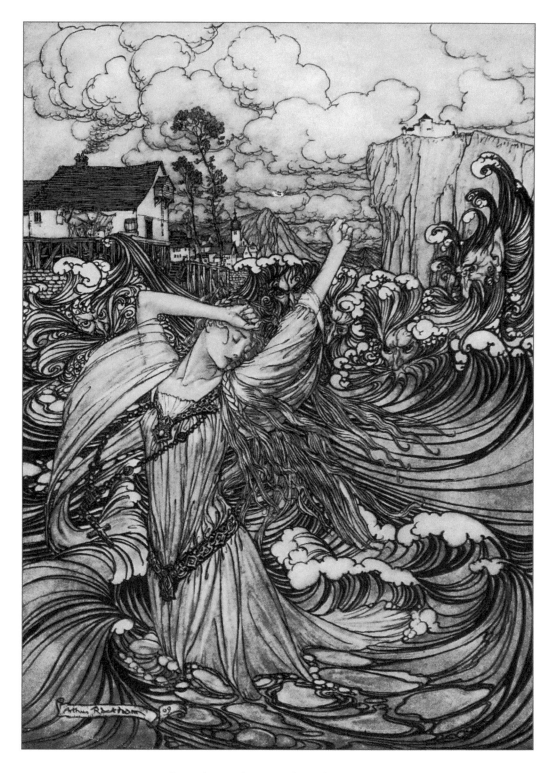

Soon she was lost to sight in the Danube.

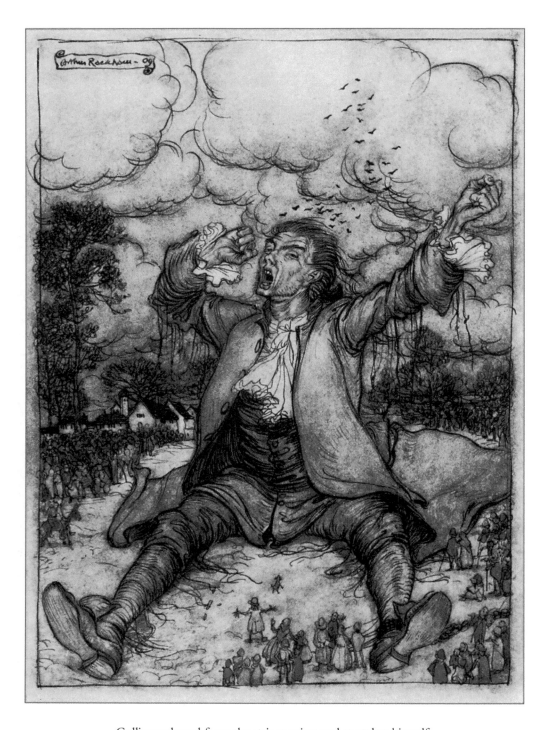

Gulliver released from the strings raises and stretches himself.

PLATE 20 **GULLIVER'S TRAVELS**

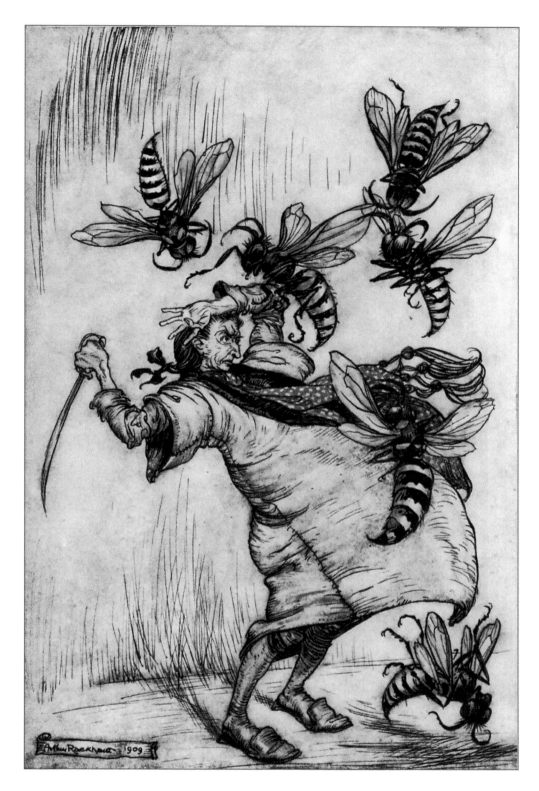

Gulliver's combat with the wasps.

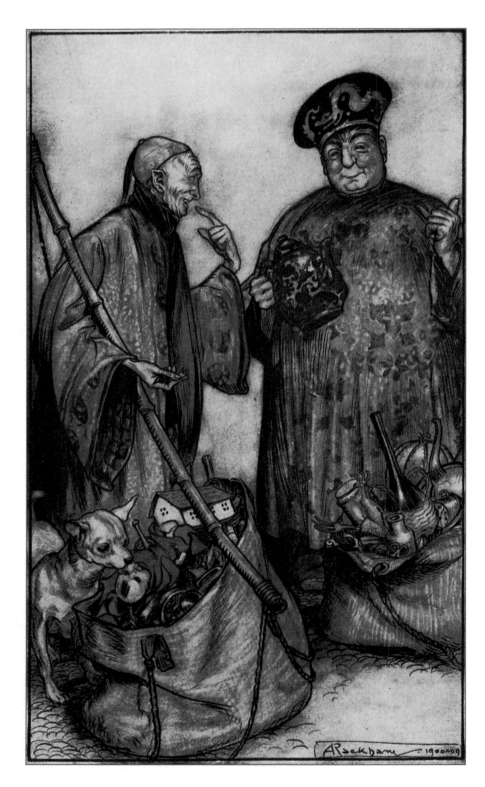

Two of those sages . . . like pedlars among us.

Plate 22 Gulliver's Travels

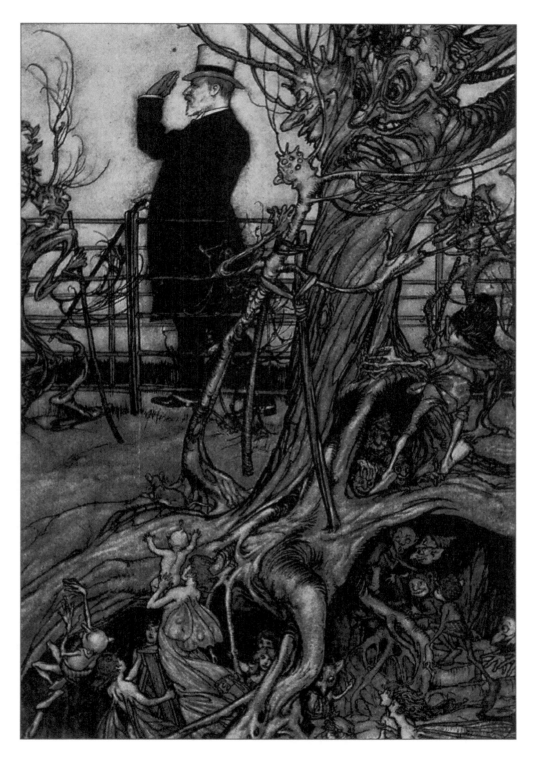

The Kensington Gardens are in London, where the King lives.

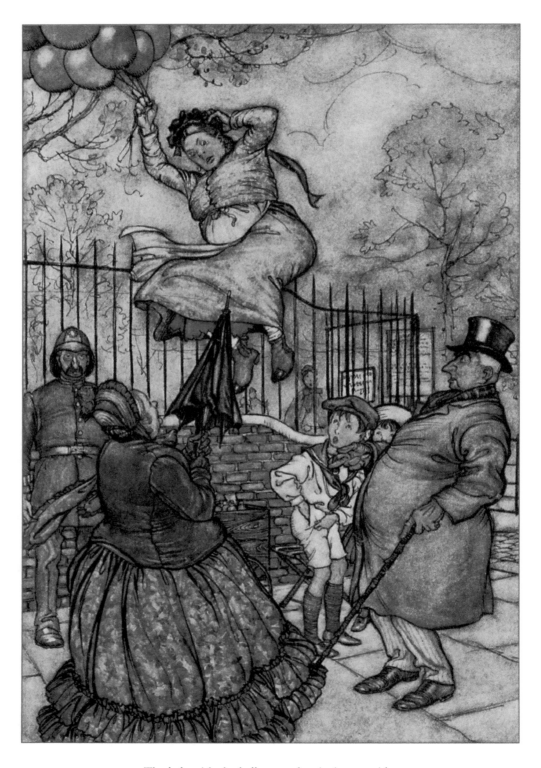

The lady with the balloons, who sits just outside.

PLATE 24 PETER PAN IN KENSINGTON GARDENS

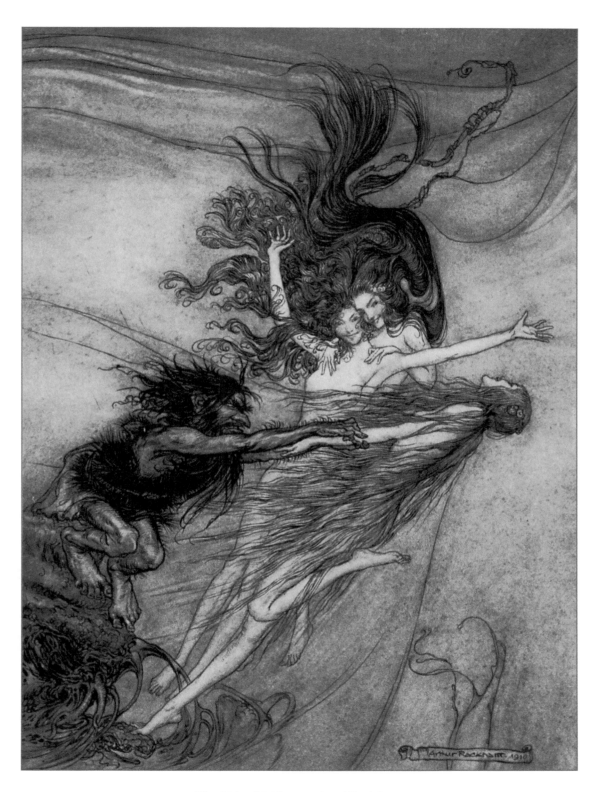

The Rhine-Maidens teasing Alberich
The Rhinegold, Scene I

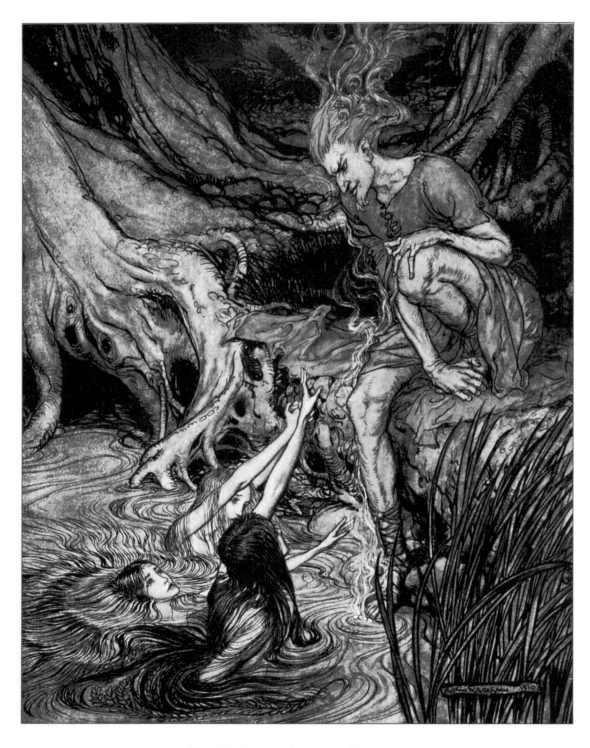

The Rhine's pure-gleaming children
Told me of their sorrow
The Rhinegold, Scene II

PLATE 26 THE RHINEGOLD & THE VALKYRIE

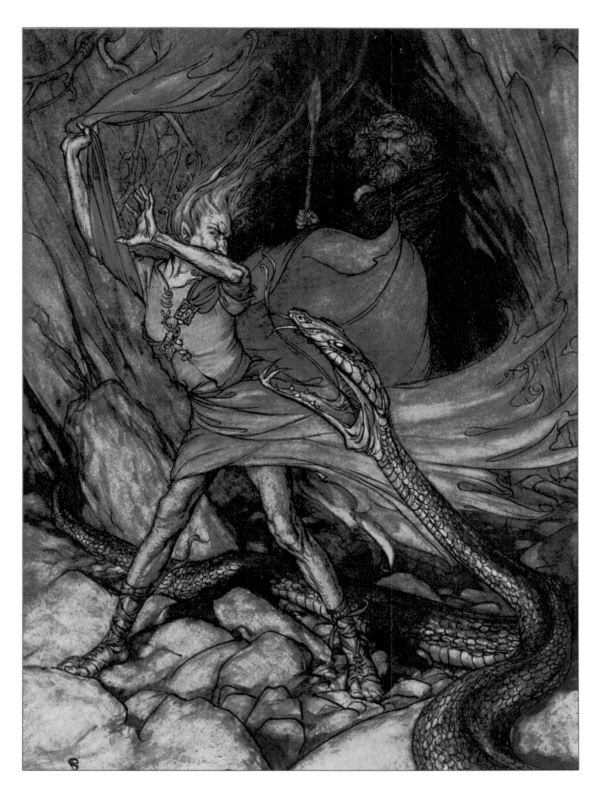

Horrible Dragon,
O swallow me not!
Spare the life of poor Loge!
The Rhinegold, Scene III

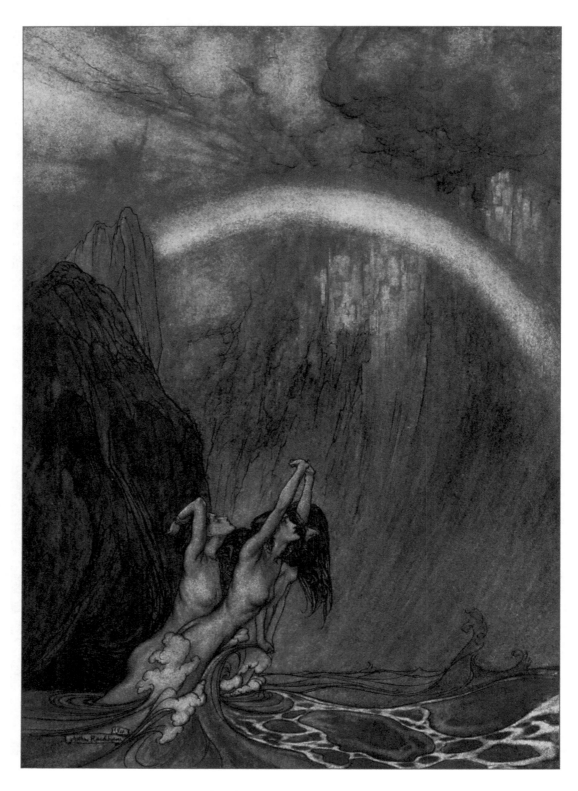

The Rhine's fair children,
Bewailing their lost gold, weep
The Rhinegold, Scene IV

PLATE 28 **THE RHINEGOLD & THE VALKYRIE**

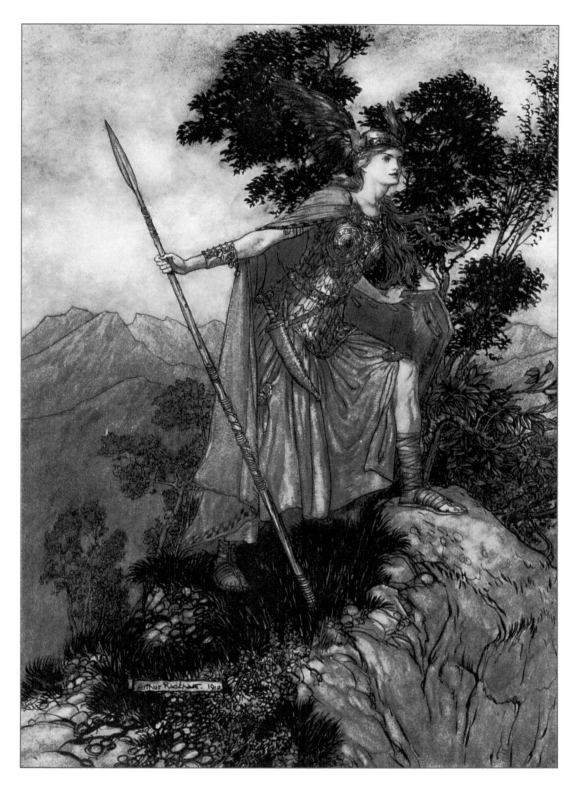

Brünnhilde
The Valkyrie; Act II

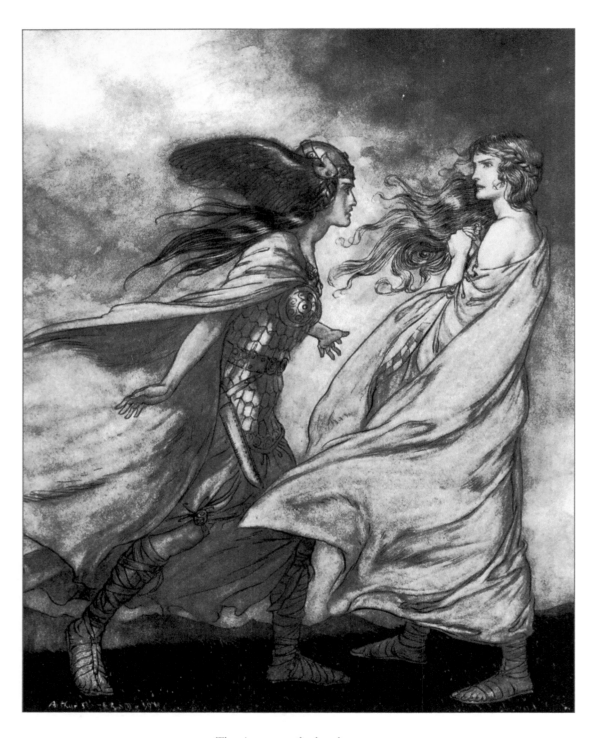

The ring upon thy hand—
. . . ah, be implored!
For Wotan Fling it away!
The Twilight of the Gods, Act I

PLATE 30 **SIEGFRIED & THE TWILIGHT OF THE GODS**

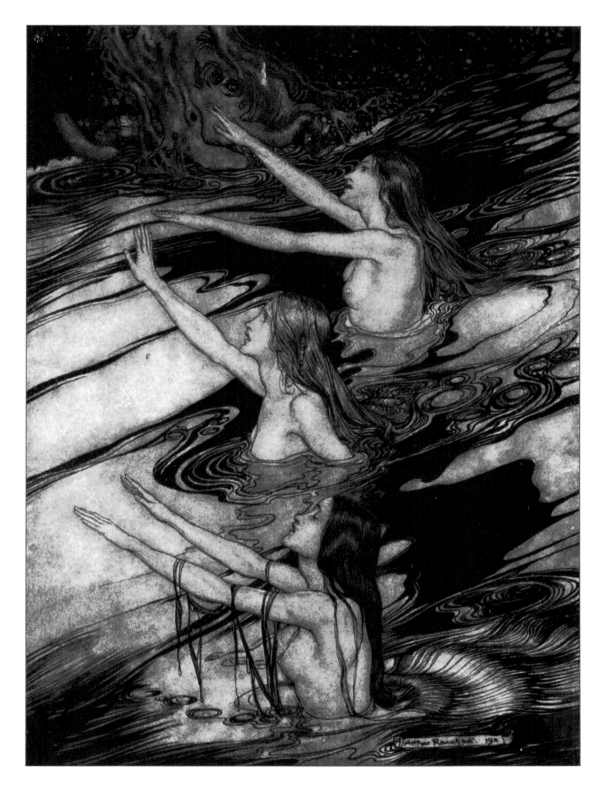

Siegfried! Siegfried!
Our warning is true:
Flee, oh, flee from the curse!
The Twilight of the Gods, Act III

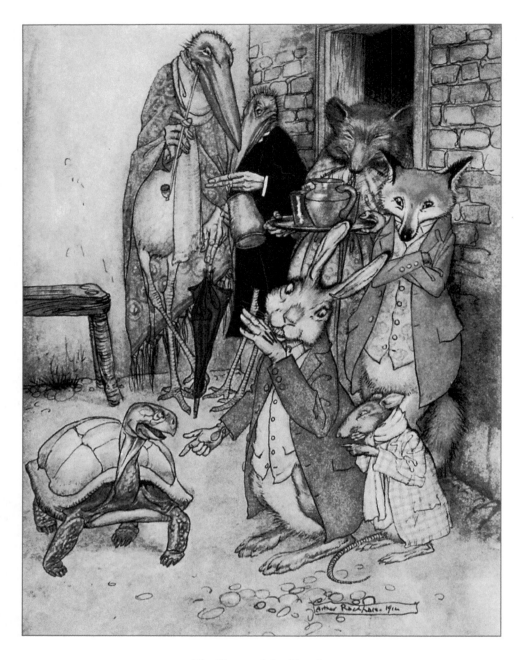

The Hare and the Tortoise

PLATE 32 AESOP'S FABLES

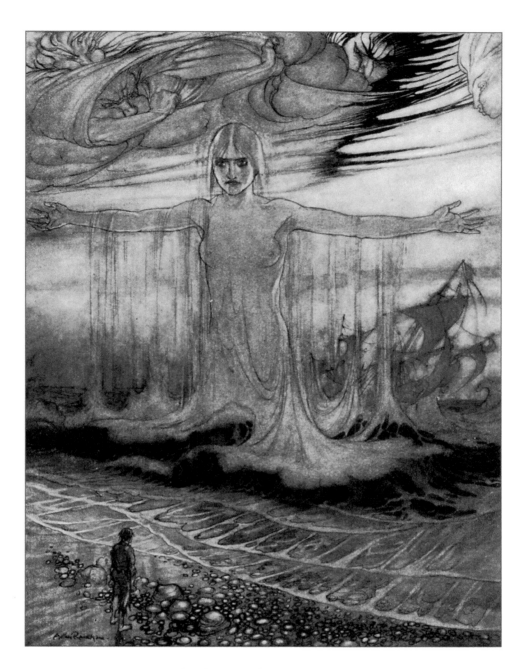

The Shipwrecked Man and the Sea

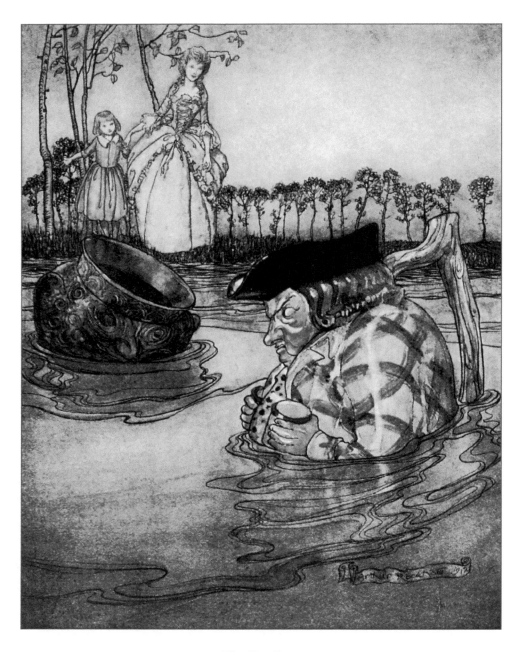

The Two Pots

Plate 34 AESOP'S FABLES

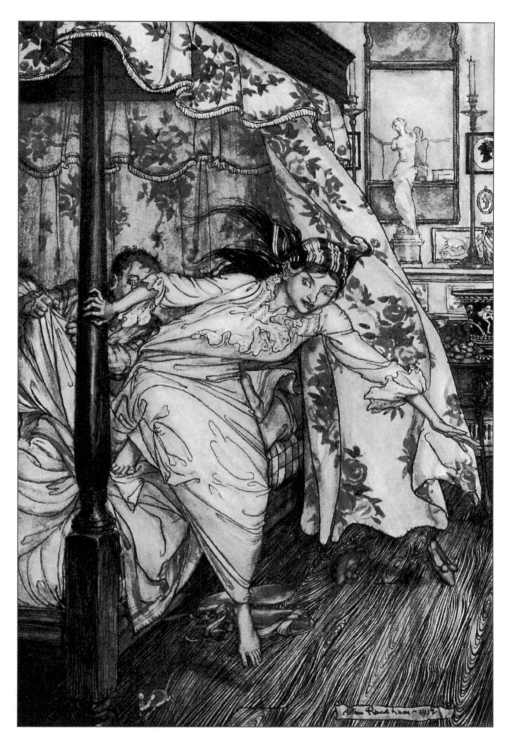

Venus and the Cat

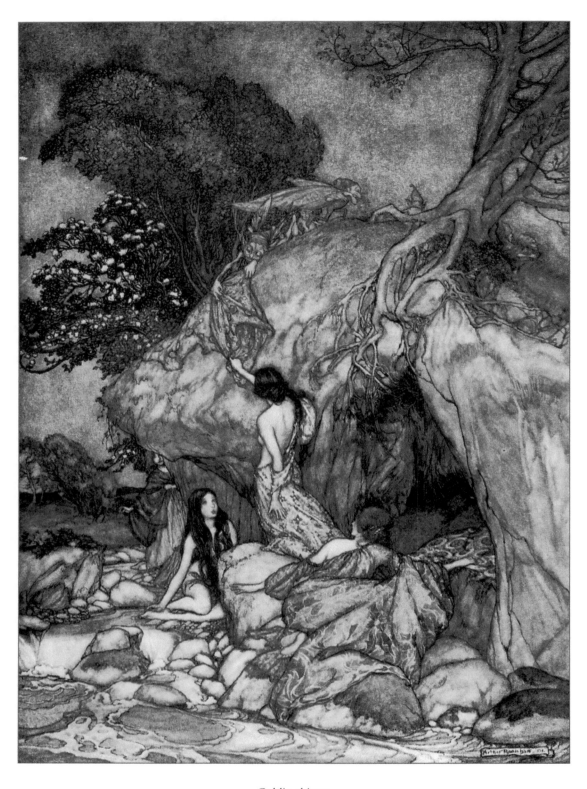

Goblin thieves

PLATE 36 ARTHUR RACKHAM'S BOOK OF PICTURES

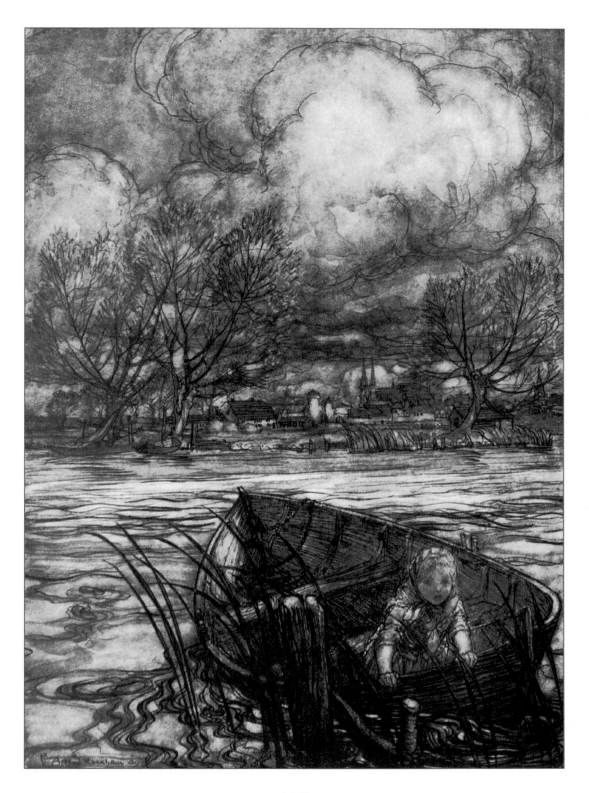

Adrift

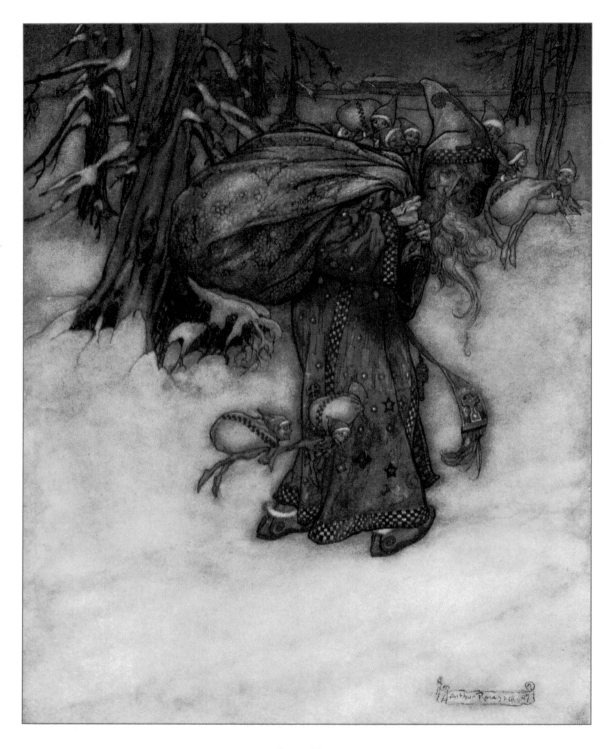

Santa Claus

PLATE 38 ARTHUR RACKHAM'S BOOK OF PICTURES

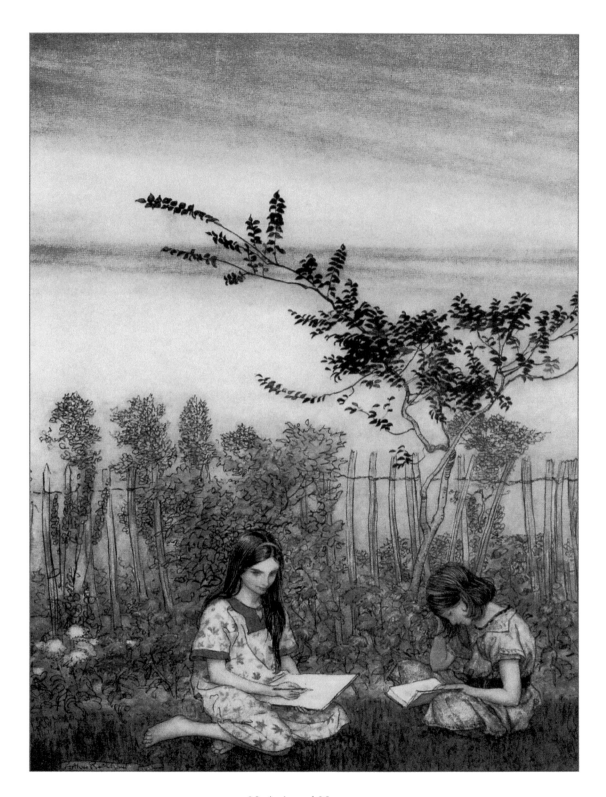

Marjorie and Margaret

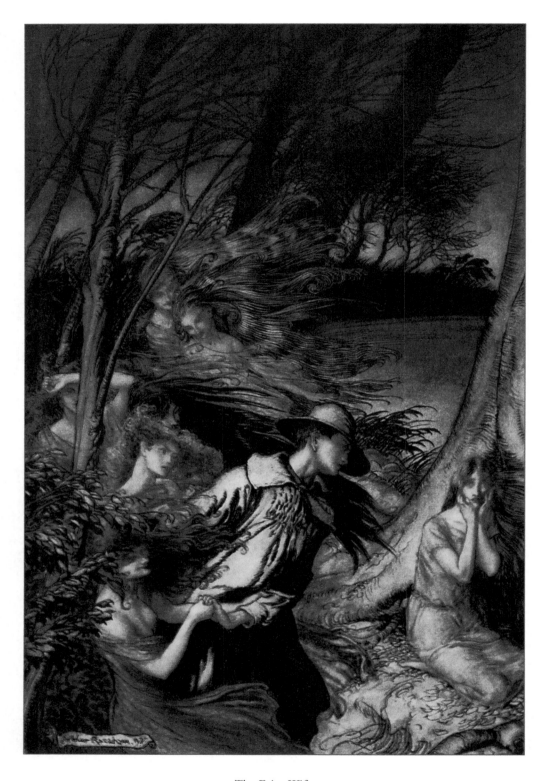

The Fairy Wife

PLATE 40 ARTHUR RACKHAM'S BOOK OF PICTURES

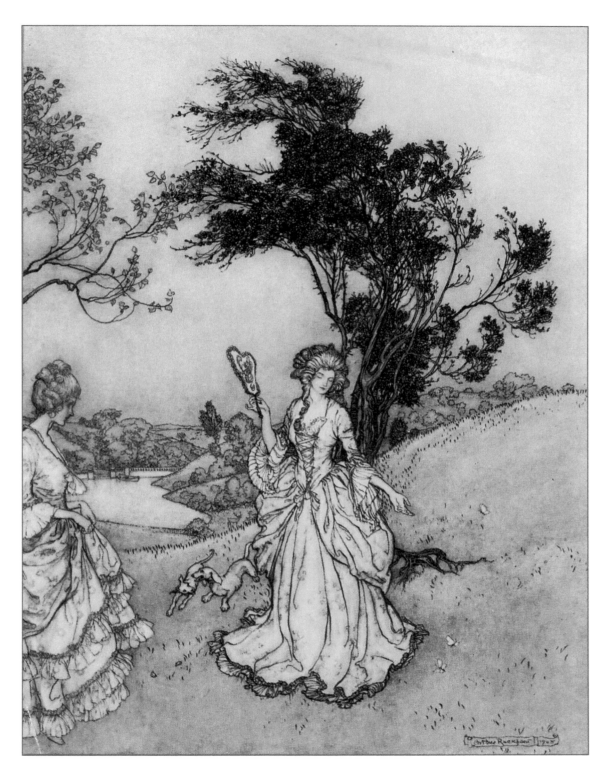

Butterflies

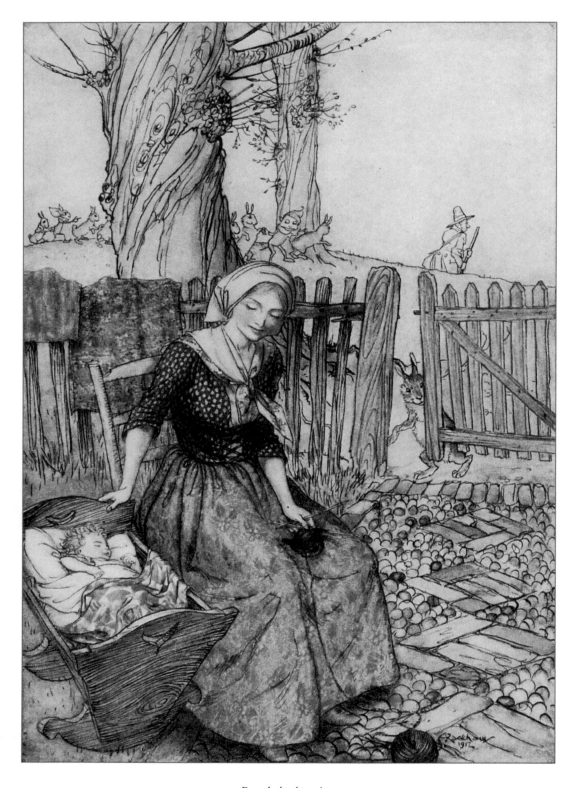

Bye, baby bunting

PLATE 42 MOTHER GOOSE

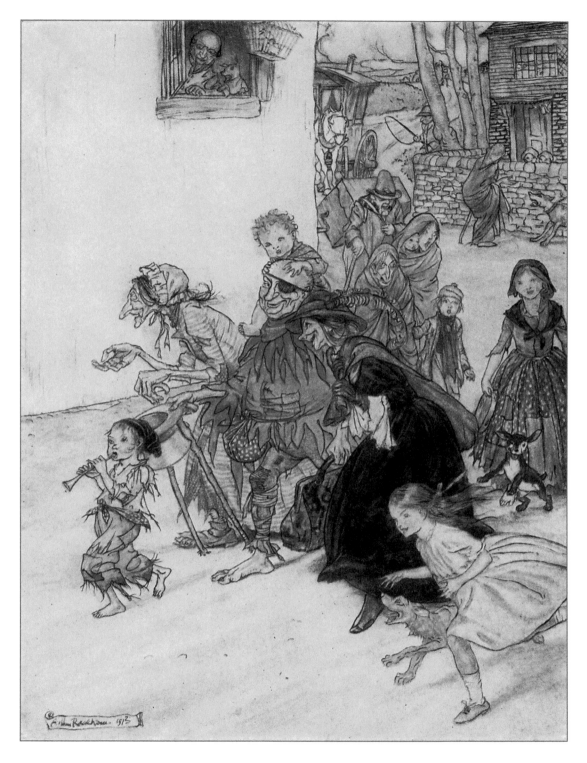

Hark, hark, the dogs do bark!

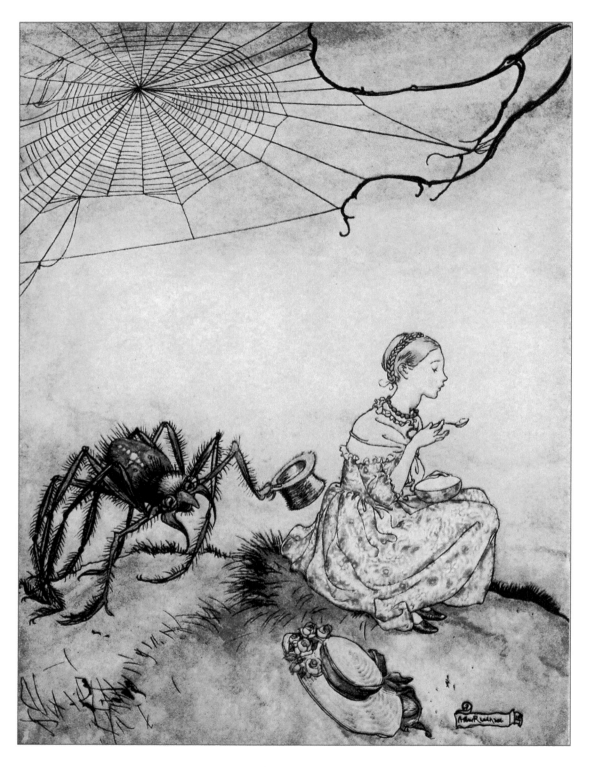

Little Miss Muffett

PLATE 44 MOTHER GOOSE

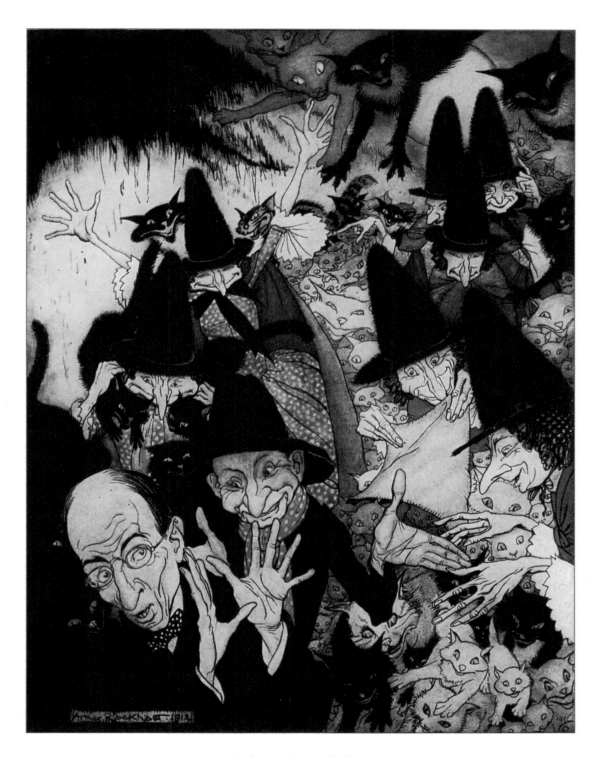

As I was going to St. Ives

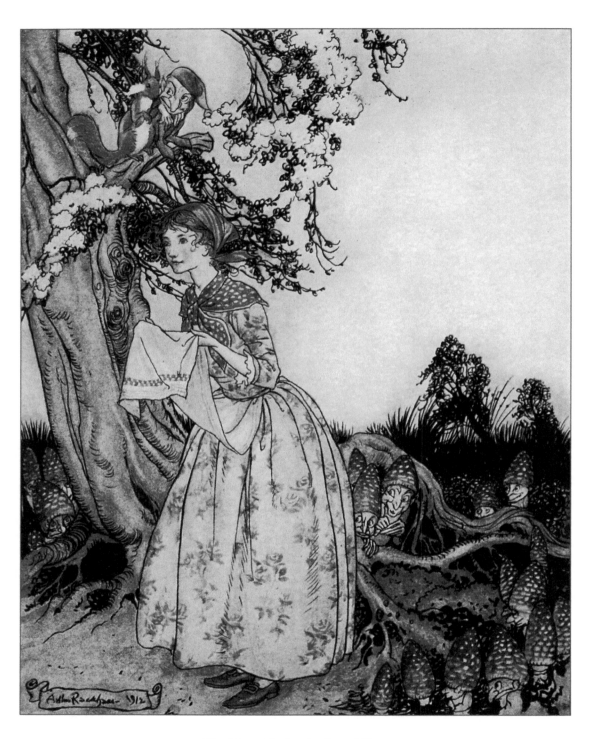

The fair maid who the first of May,
Goes to the fields at break of day

PLATE 46 MOTHER GOOSE

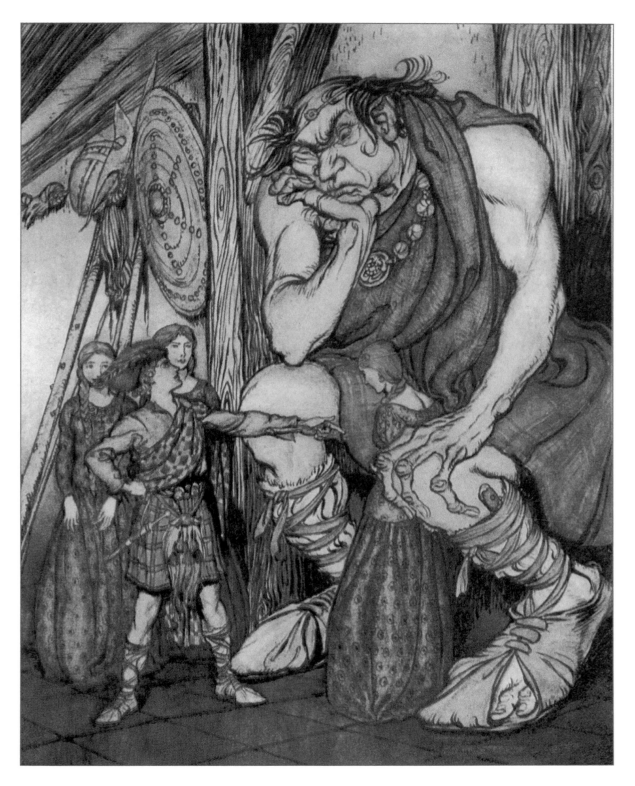

"If thou wilt give me this pretty little one," says the king's son, "I wil take thee at thy word."
From "The Battle of the Birds"

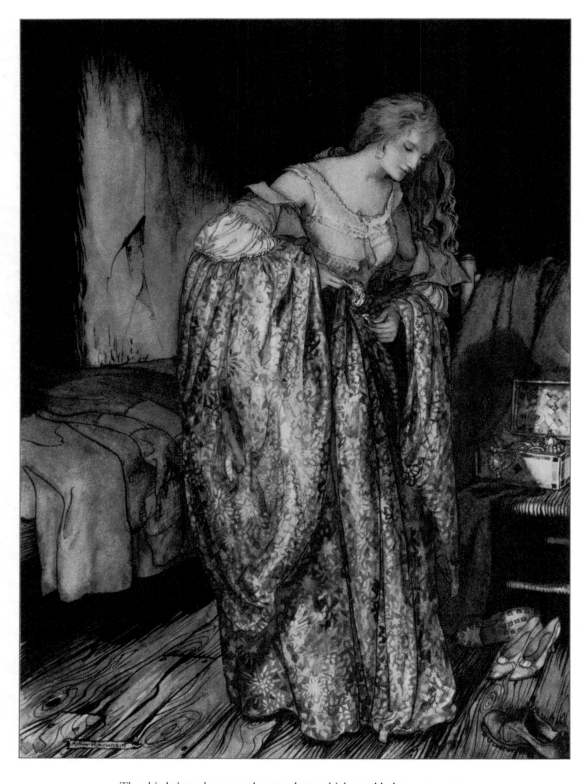

The third time she wore the star-dress which sparkled at every step.
From "The True Sweetheart"

PLATE 48 LITTLE BROTHER AND LITTLE SISTER AND OTHER TALES

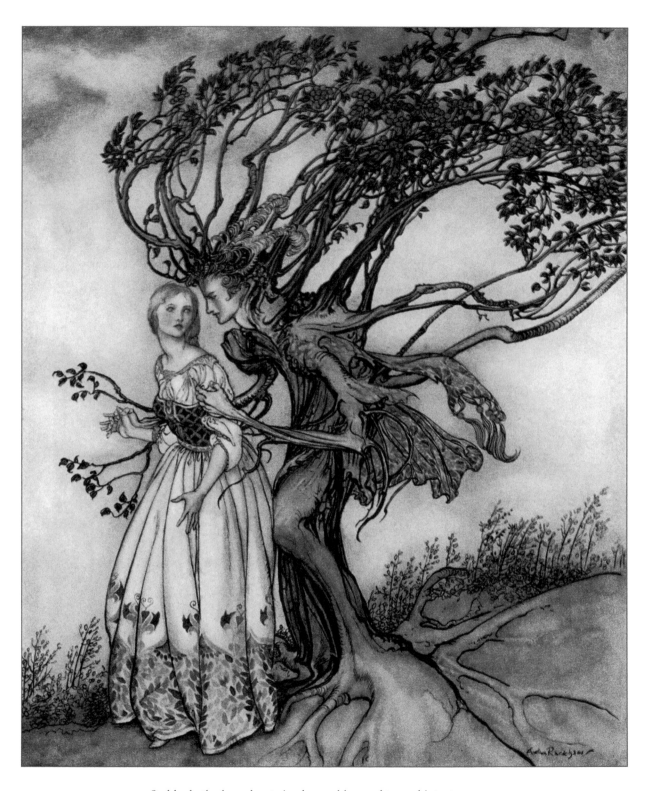

Suddenly the branches twined round her and turned into two arms.
From "The Old Woman in the Wood"

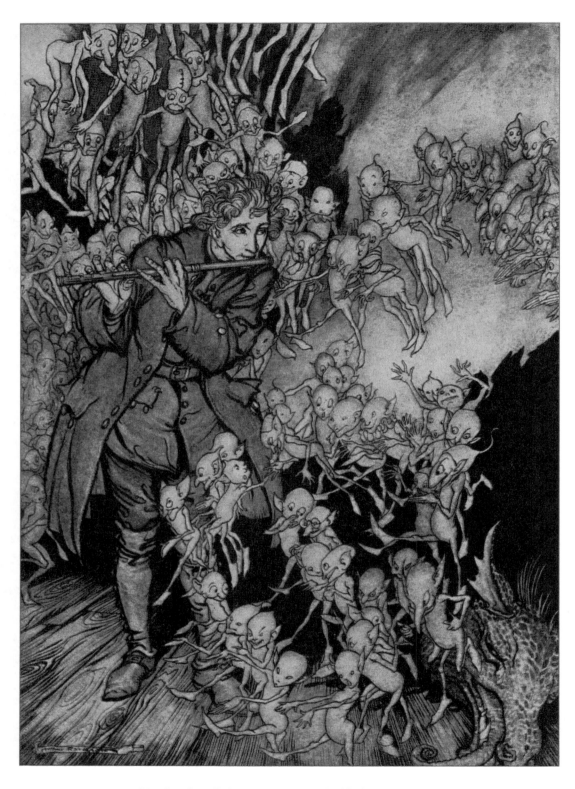

He played until the room was entirely filled with gnomes.
From "The Gnomes"

PLATE 50 LITTLE BROTHER AND LITTLE SISTER AND OTHER TALES

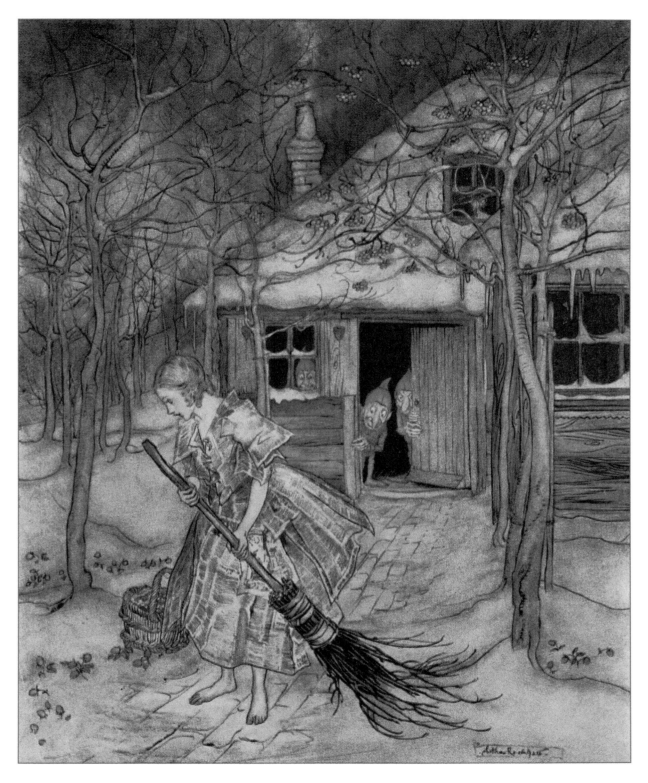

What did she find there but real ripe strawberries.
From "The Three Little Men in the Wood"

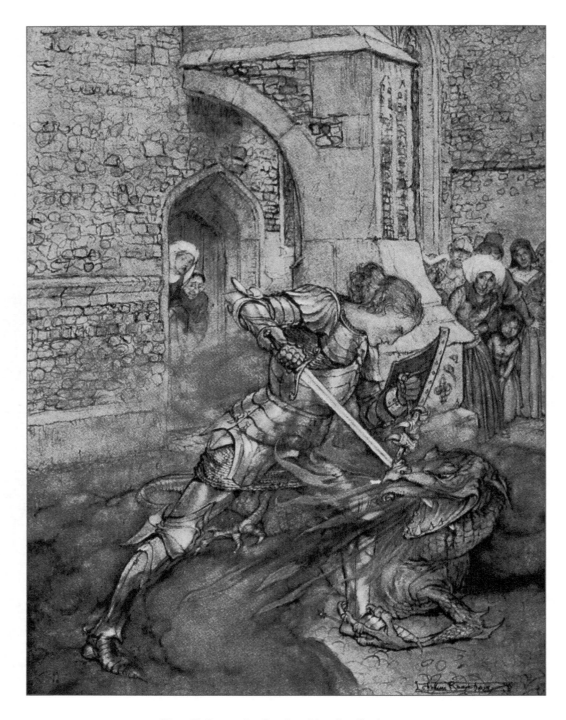

How Sir Launcelot fought with a fiendly dragon.

PLATE 52 THE ROMANCE OF KING ARTHUR

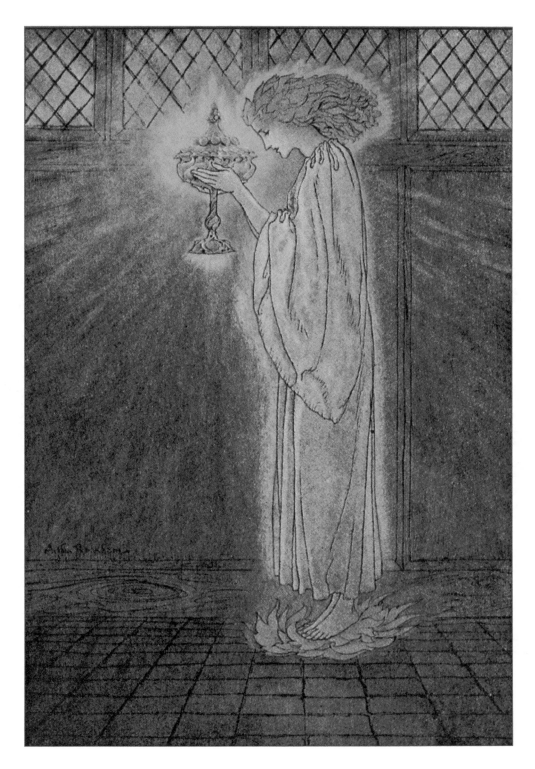

How at the Castle of Corbin a maiden bare in the Sangreal
and foretold the achievements of Galahad.

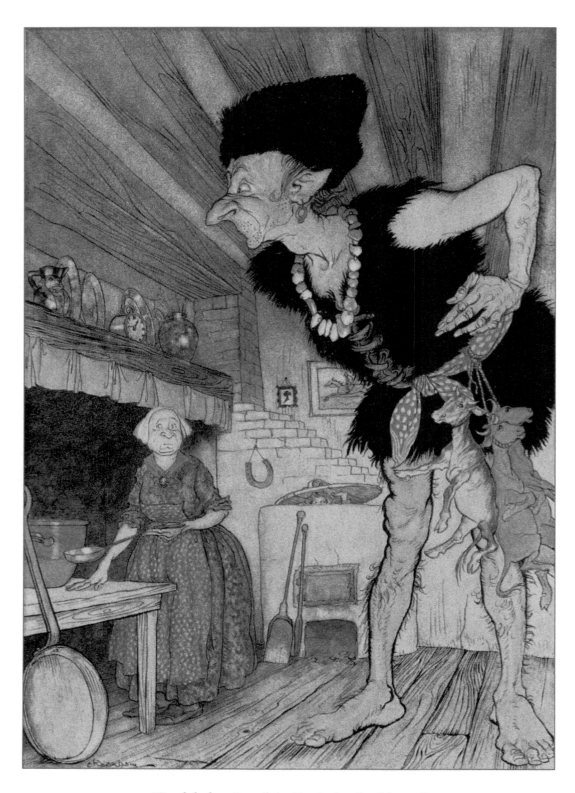

"Fee-fi-fo-fum, I smell the blood of an Englishman."
From "Jack and the Beanstalk"

PLATE 54 ENGLISH FAIRY TALES

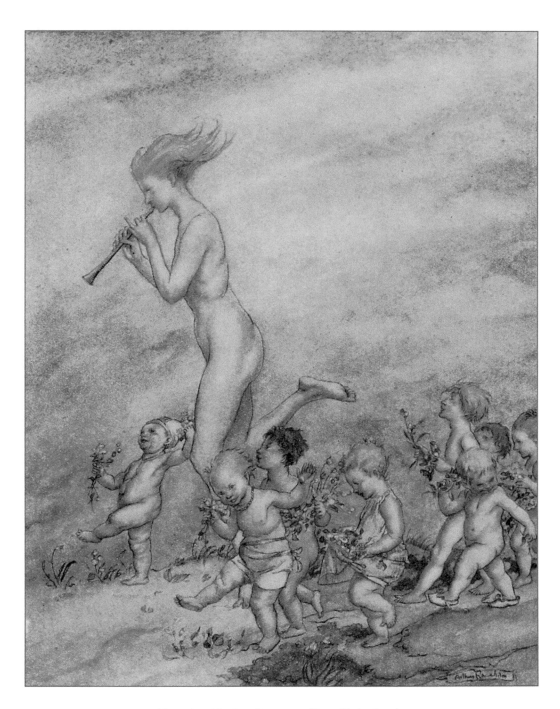

Now that May's call musters files of baby hands

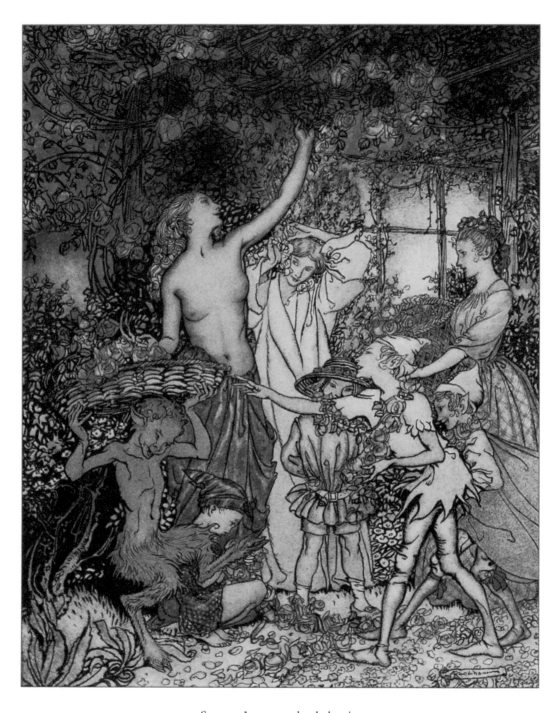

Summer's rose-garlanded train

PLATE 56 THE SPRINGTIDE OF LIFE

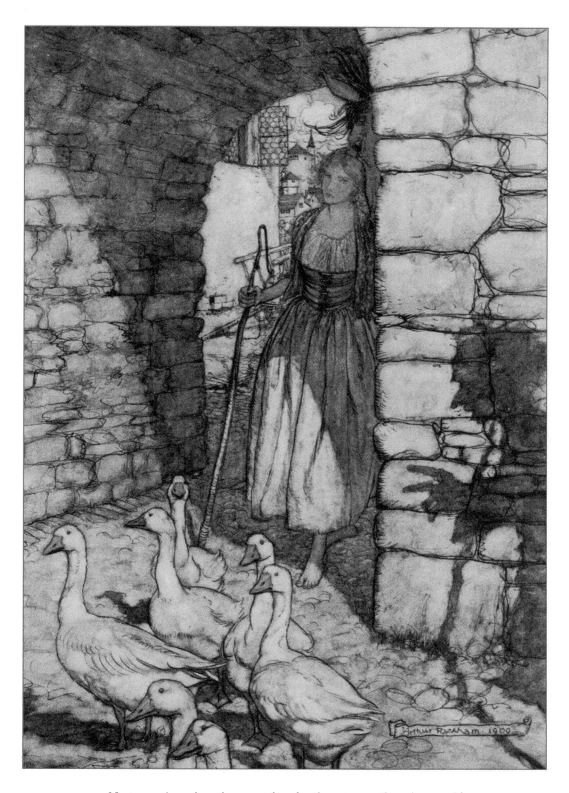

Next morning when they passed under the gateway, the princess said
"Alas! Dear Falada, there thou hangest."
From "The Goosegirl"

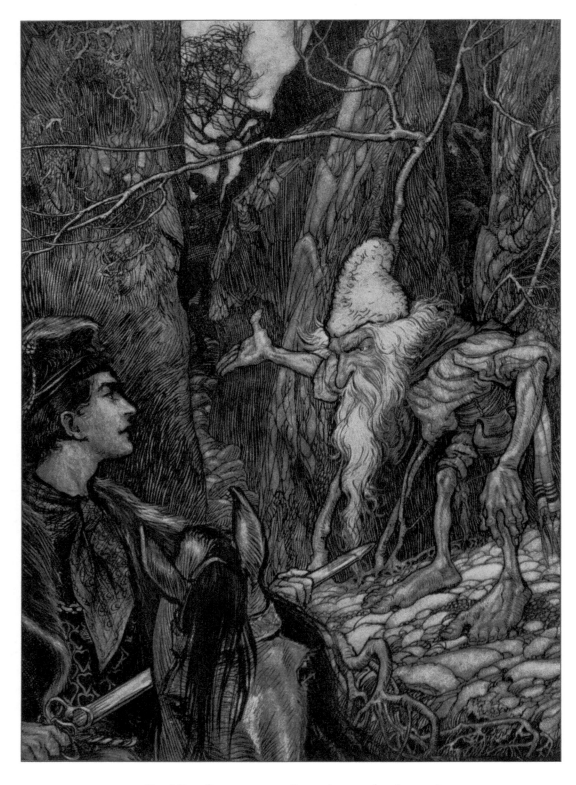

Good Dwarf, can you not tell me where my brothers are?
From "The Water of Life"

PLATE 58 SNOWDROP AND OTHER TALES

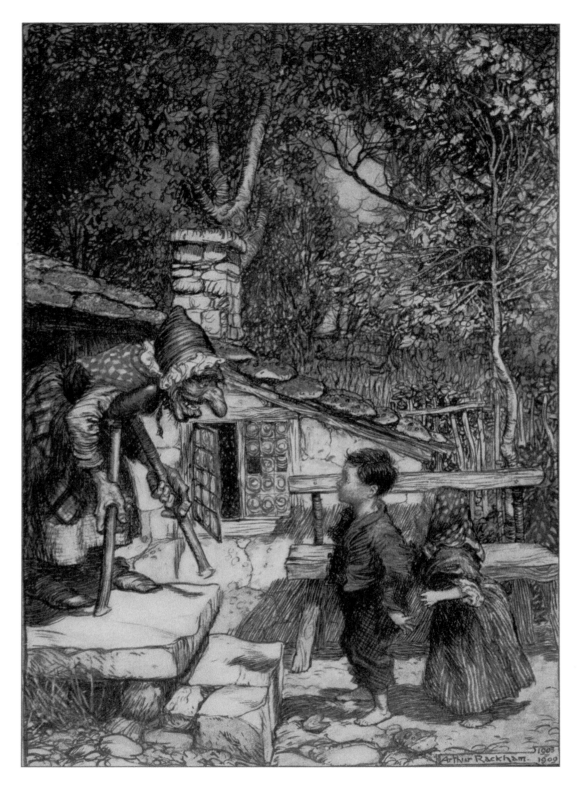

All at once the door opened and an old, old woman,
supporting herself on a crutch, came hobbling out.
From "Hansel and Grethel"

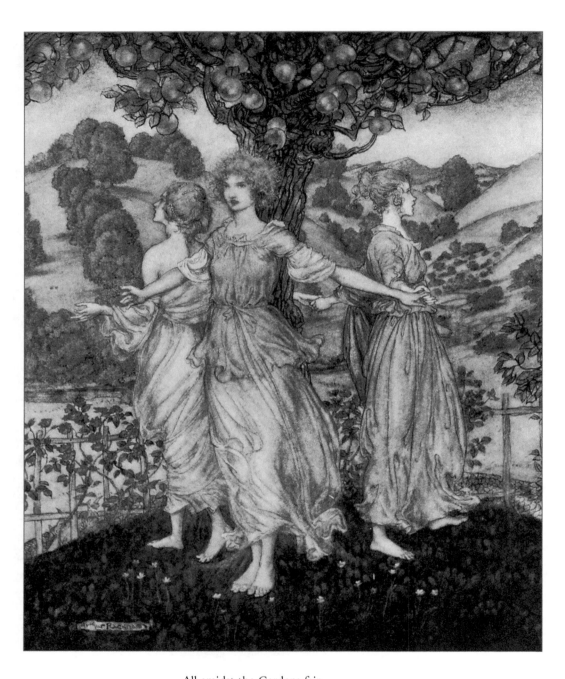

All amidst the Gardens fair
Of Hesperus, and his daughters three
That sing about the golden tree.

PLATE 60 COMUS

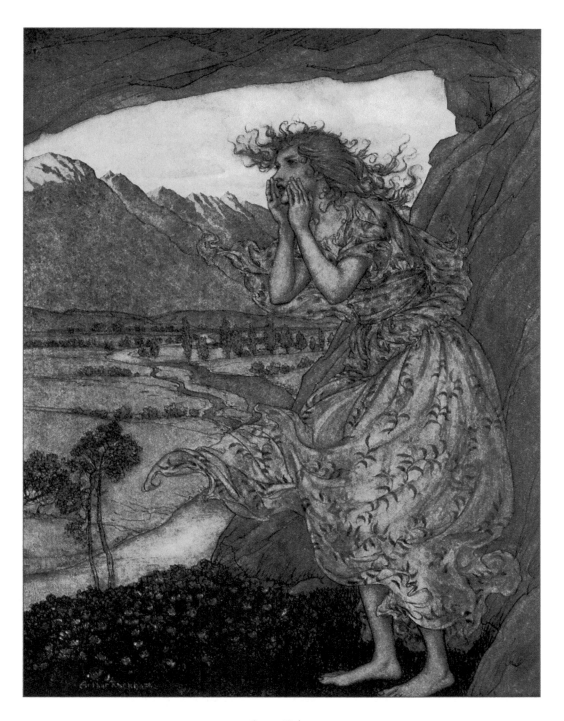

Sweet Echo

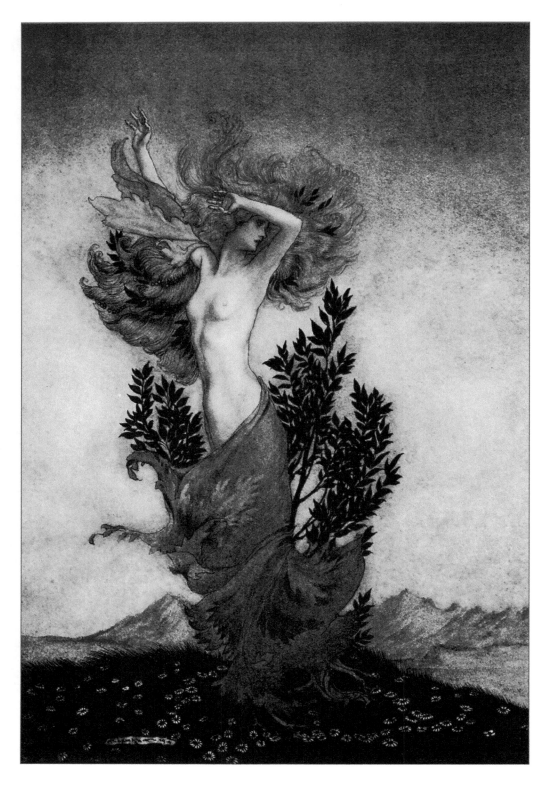

. . . . as Daphne was,
Root-bound, that fled Apollo.

PLATE 62 COMUS

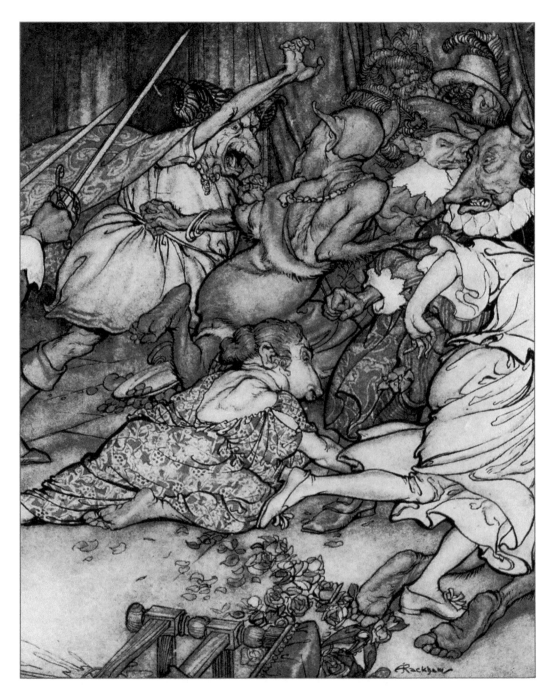

The Brothers rush in with swords drawn.

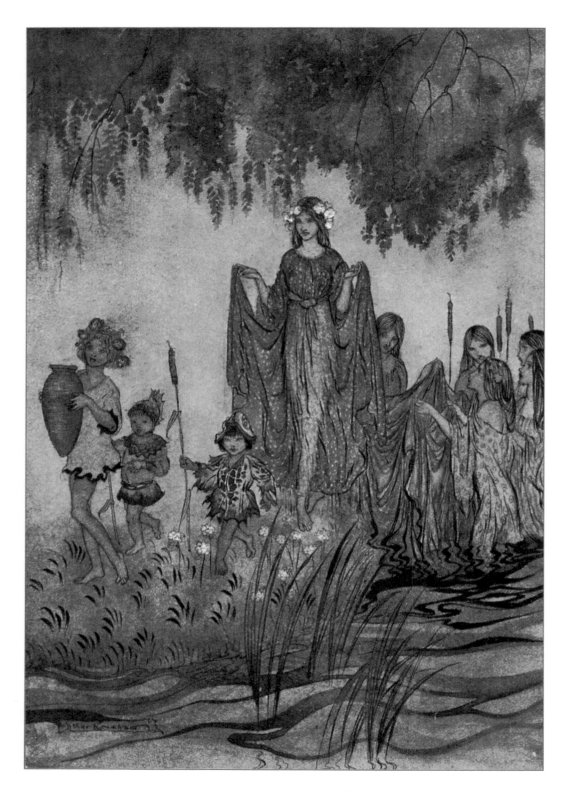

Sabrina rises, attended by water-Nymphs.

PLATE 64 COMUS

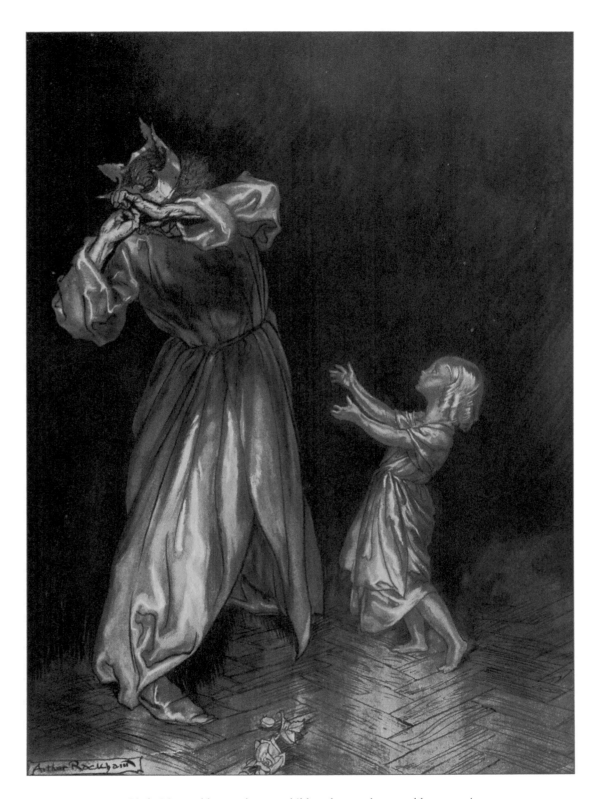

Little Marygold was a human child no longer, but a golden statue!
From "The Golden Touch"

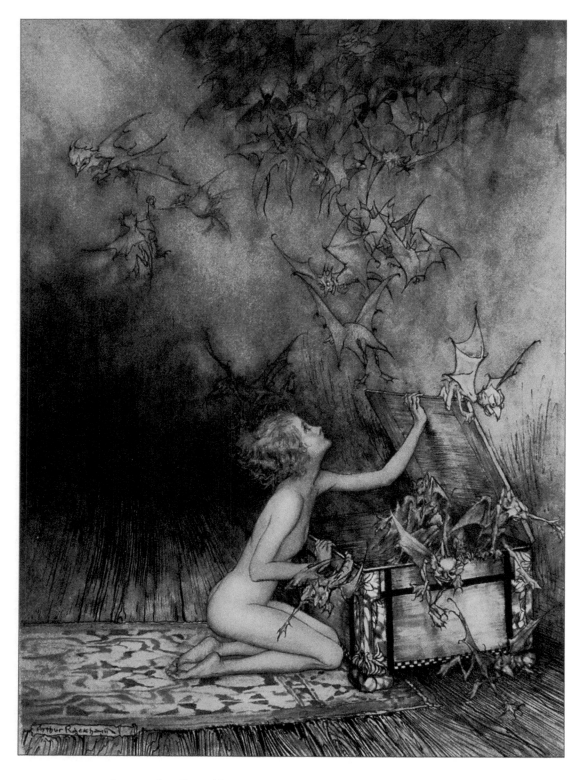

It seemed as if a sudden swarm of winged creatures brushed past her.
From "The Paradise of Children"

PLATE 66 **A WONDER BOOK**

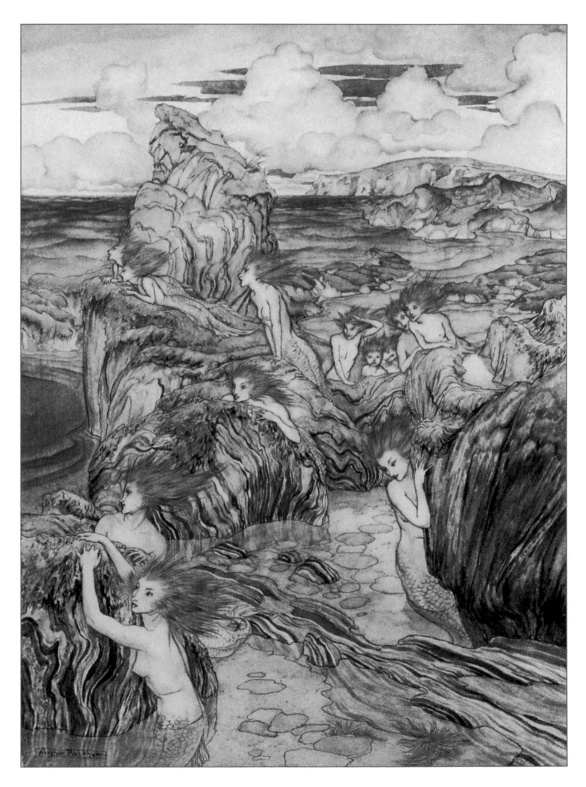

We do not think it proper to be acquainted with them,
because they have sea-green hair, and taper away like fishes.
From "The Three Golden Apples"

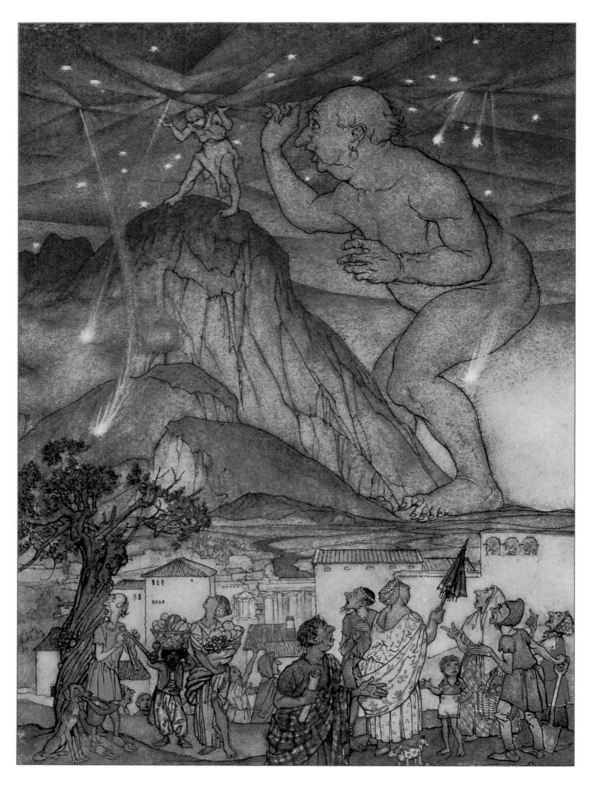

Hercules gave a great shrug of his shoulders. It being now twilight,
you might have seen two or three stars tumble out of their places.
From "The Three Golden Apples"

PLATE 68 **A WONDER BOOK**

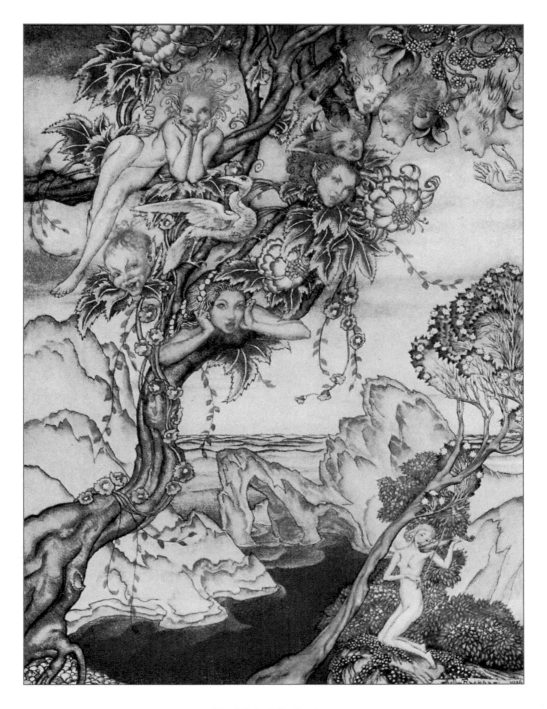

The isle is full of noises,
Sounds and sweet airs, that give delight and hurt not
Act III, Scene II

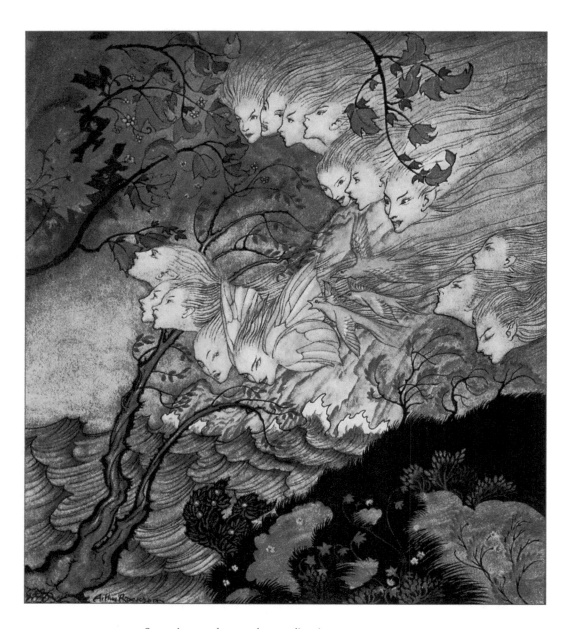

Sometimes a thousand twangling instruments
Will hum about mine ears, and sometimes voices
Act III, Scene II

PLATE 70 THE TEMPEST

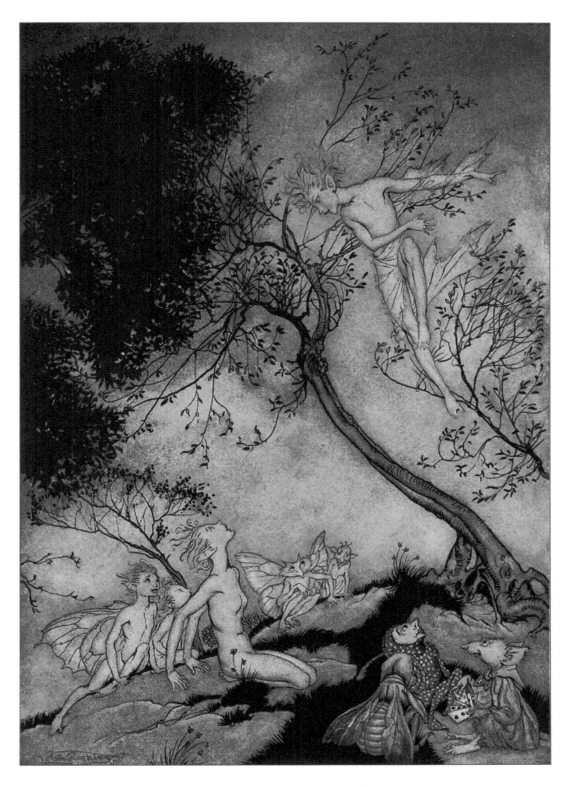

Go bring the rabble
O'er whom I give thee power, here to this place
Act IV, Scene I

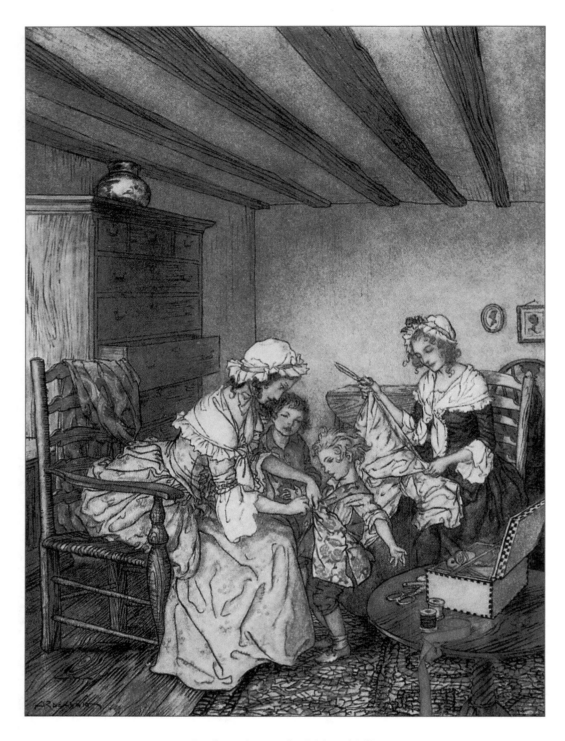

Sunday waistcoats for Dick and Bill.

PLATE 72 THE VICAR OF WAKEFIELD

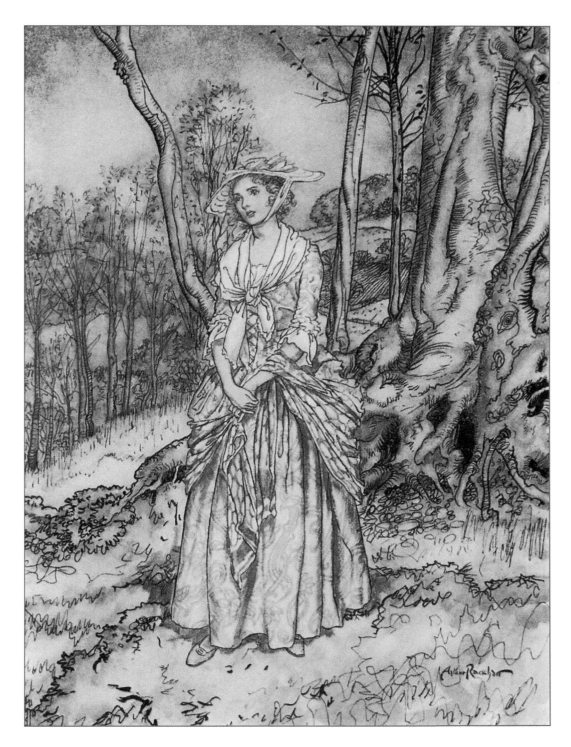

That little melancholy air your papa was so fond of.

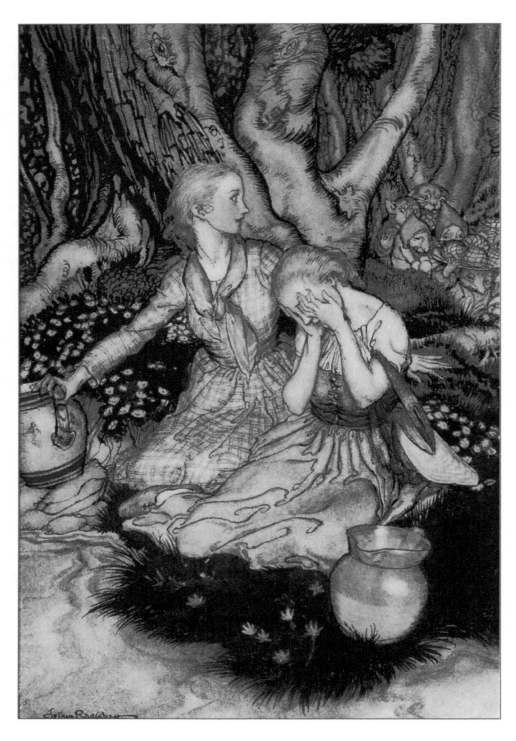

"Look, Lizzie, look, Lizzie,
Down the glen tramp little men"

PLATE 74 GOBLIN MARKET

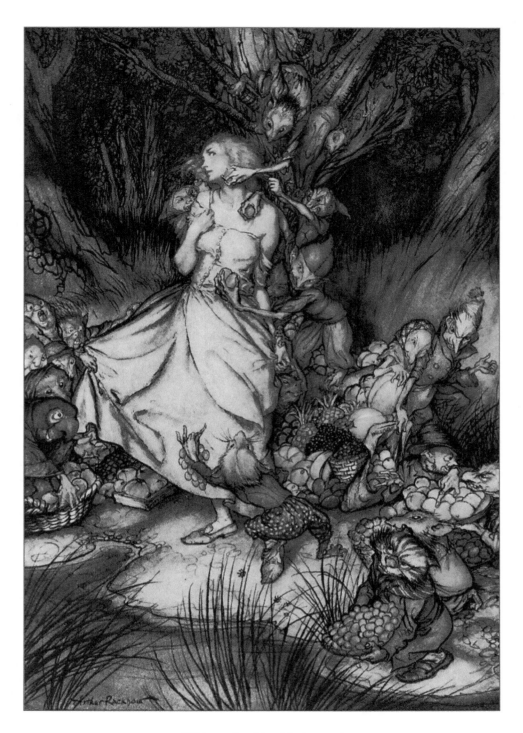

White and golden Lizzie stood

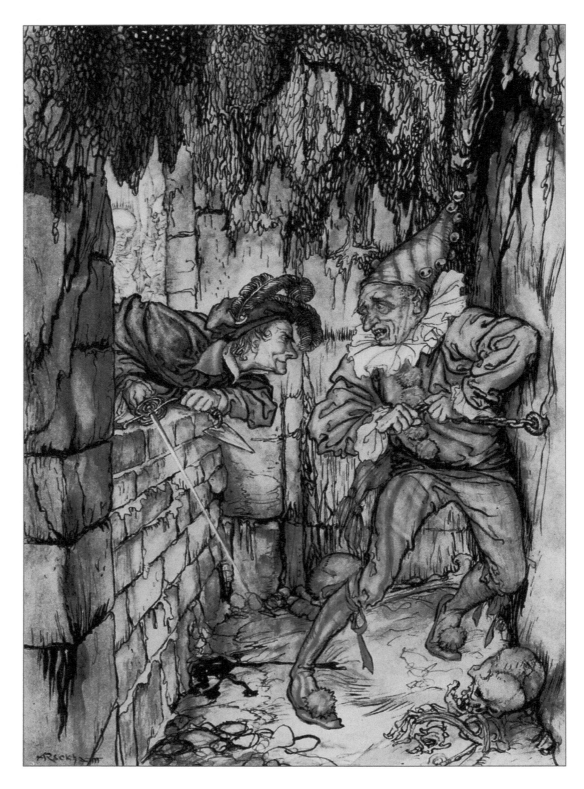

The wall was now nearly upon a level with my breast.
Unsheathing my rapier, I began to grope with it about the recess.
From "The Cask of Amontillado"

PLATE 76 TALES OF MYSTERY AND IMAGINATION

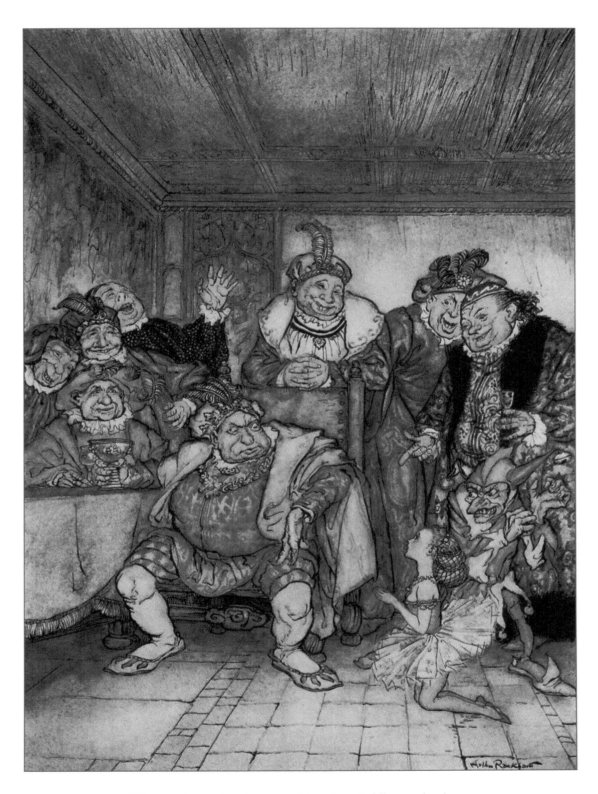

Tripetta advanced to the monarch's seat, and, falling on her knees
before him, implored him to spare her friend.
From "Hop-Frog"

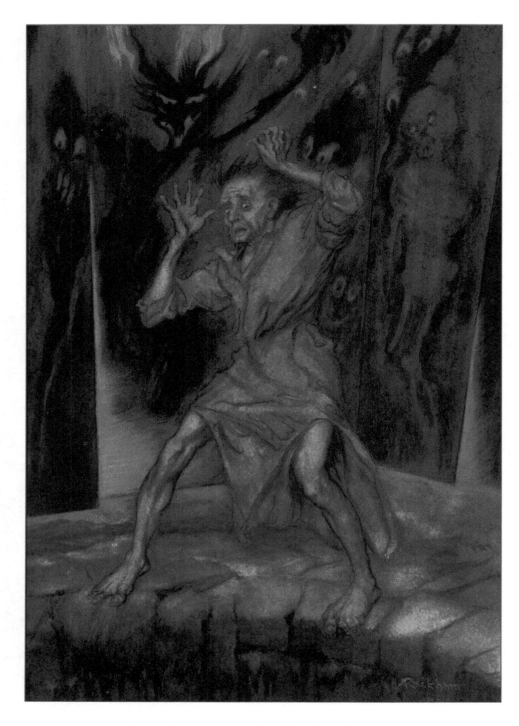

At length for my seared and writhing body there was no
longer an inch of foothold on the firm floor of the prison.
From "The Pit and the Pendulum"

PLATE 78 TALES OF MYSTERY AND IMAGINATION

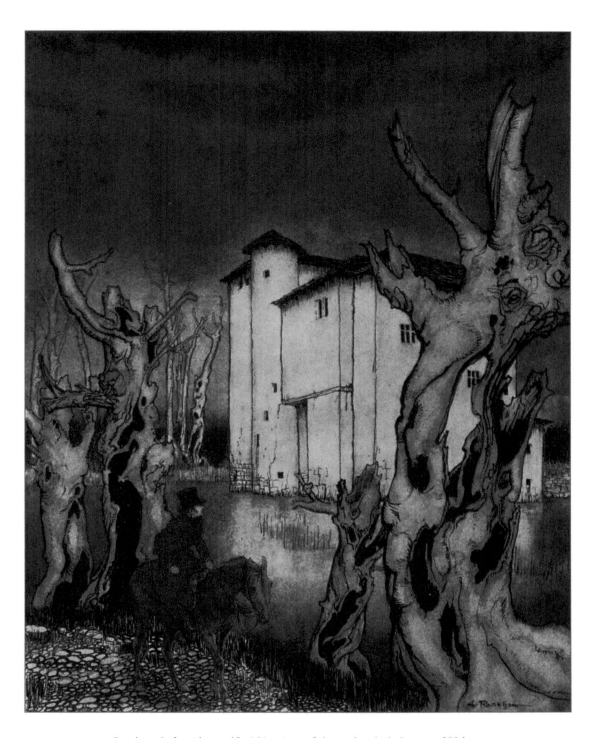

I at length found myself within view of the melancholy house of Usher.
From "The Fall of the House of Usher"

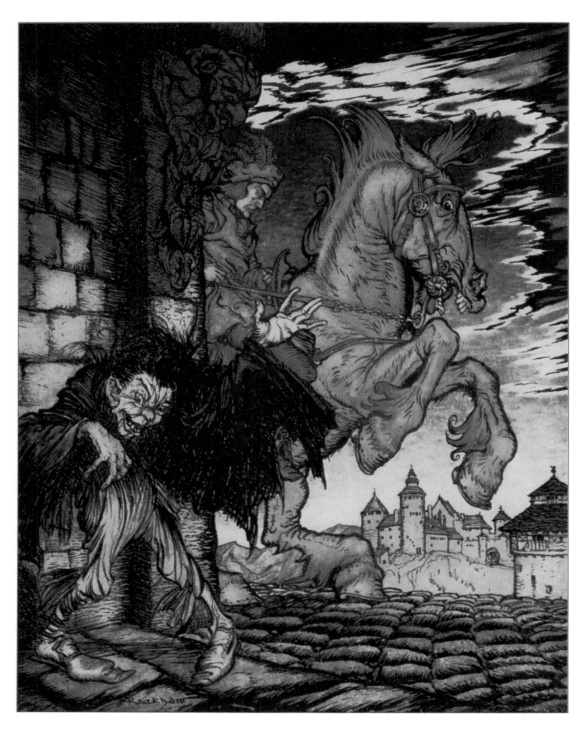

The young Metzengerstein seemed riveted to the saddle of that colossal horse.
From "Metzengerstein"

PLATE 80 TALES OF MYSTERY AND IMAGINATION

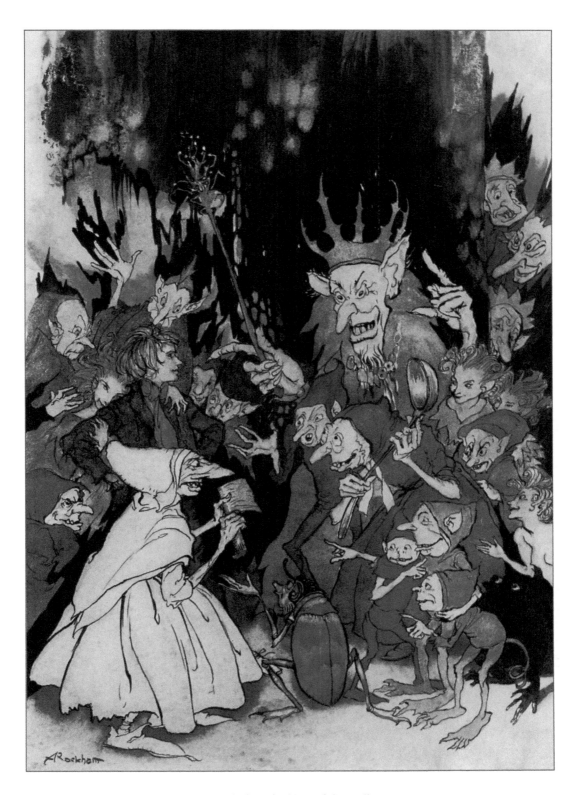

Peer before the king of the trolls.

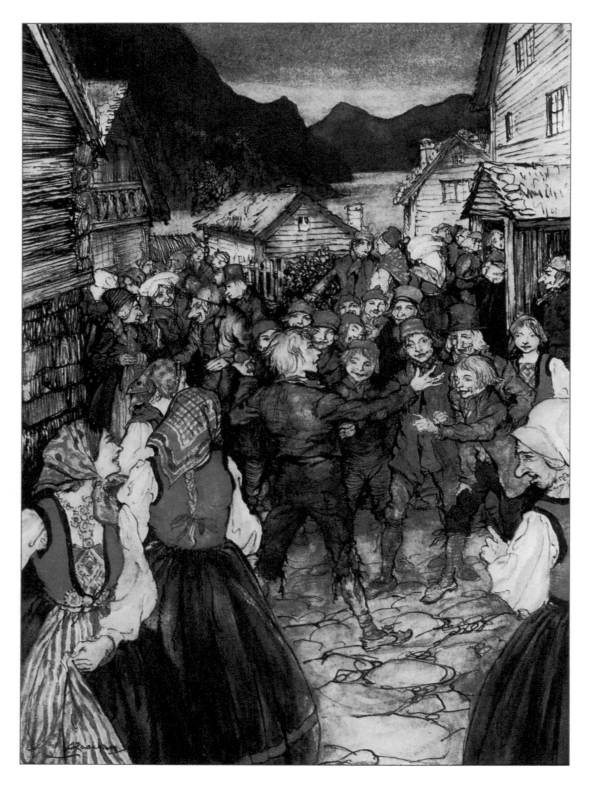

Peer among the wedding guests.

PLATE 82 PEER GYNT

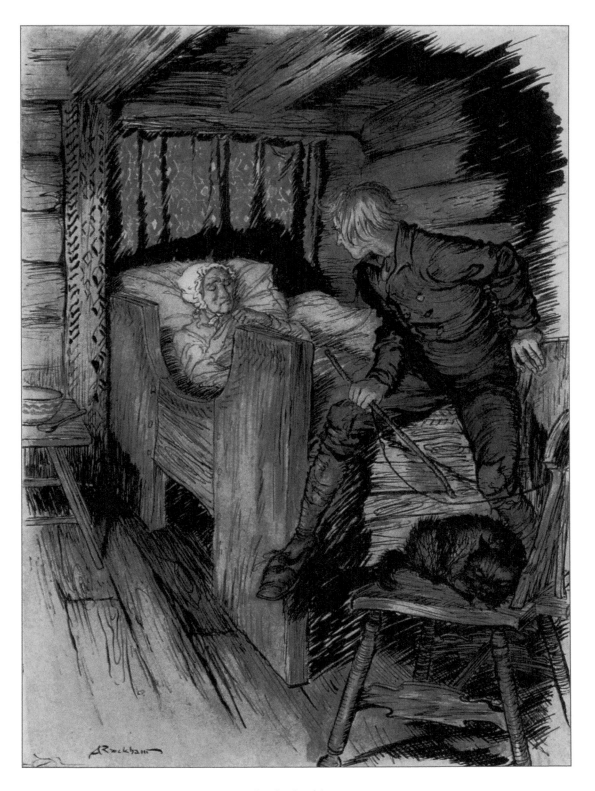

The death of Aase.

PEER GYNT PLATE 83

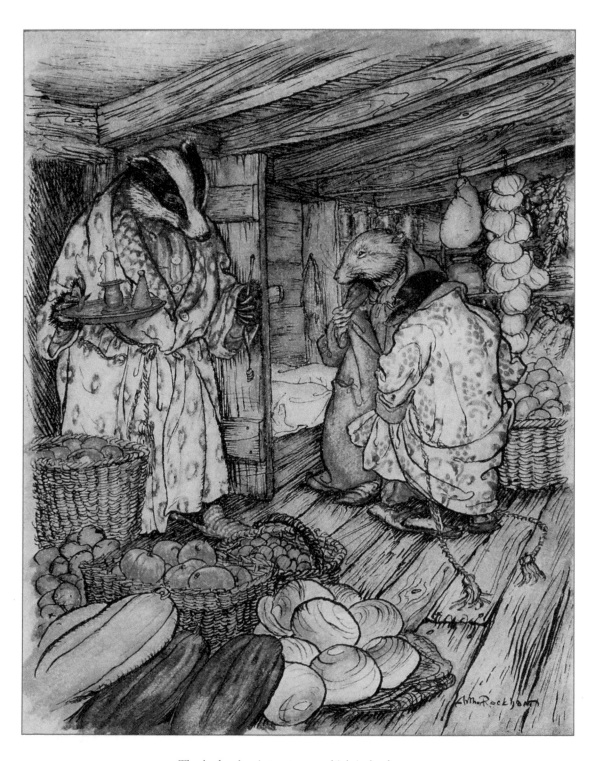

The badger's winter stores, which indeed were
visible everywhere, took up half the room.

PLATE 84 THE WIND IN THE WILLOWS

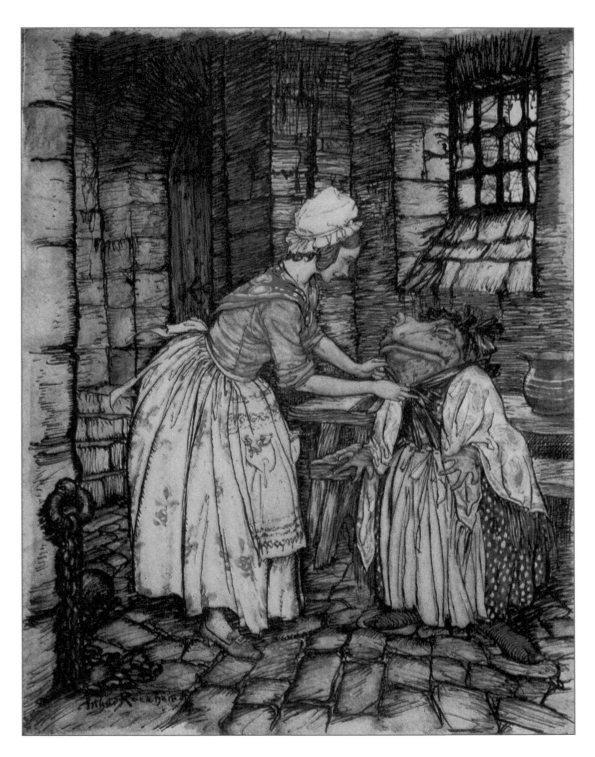

She arranged the shawl with a profesional fold, and tied the
strings of the rusy bonnet under his chin.

The End